IMAGES
of America

CHICAGO'S SOUTH SHORE

COUNTRY CLUB

William M. Krueger

ARCADIA

Published by Arcadia Publishing,
an imprint of Tempus Publishing, Inc.
3047 N. Lincoln Ave., Suite 410
Chicago, IL 60657

Printed in Great Britain.

Library of Congress Catalog Card Number: 2001092769

For all general information contact Arcadia Publishing at:
Telephone 843-853-2070
Fax 843-853-0044
E-Mail sales@arcadiapublishing.com

For customer service and orders:
Toll-Free 1-888-313-2665

Visit us on the internet at http://www.arcadiapublishing.com

For my wife Kathleen, who supports my every interest and is my inspiration.
For my daughters Heather and Ashley, for all of your help and unconditional love.
For my parents Vera and William, who have provided a lifetime of interest and
encouragement and who remain my heroes.

CONTENTS

Acknowledgments

This book would not have been possible without the assistance and support of the following people. Thanks for the help and guidance provided by Charles Celander and Melani Davis. Thanks to their daughters Jenny and Anna for their help and for allowing me to borrow their dad. A special thanks to Loretta Gliege for a lifetime of encouragement, and to Bud and Alice Swift, and Mary Jane Carroll for your enthusiasm. Many thanks to Dennis, Beverly, and Jon Pavesic for listening to my endless stories and for still showing interest in more. Sincere thanks to Linda Williamson, an adventurer and kindred spirit who also bonds with the past, Karen Romano for always agreeing with me, and Alice Lowe for your support and positive words. Thank you to Lawrence Heyworth Jr. for supplying historical information and photographs from his personal collection. Thanks to Lester Hunt and Jack Simmerling for helping to cultivate my interest in Chicago history. Thank you to my first grade teacher Jacquelyne J. Mooney of Charles Carroll School for instilling my love of reading. Special thanks to Terry O'Malley, John Madden, Jim Jedinak, John Aranza, Jan Foody, the Gliege family, Edgar Jeswein, Louise Schiff, Ted and Rose Zane, Polly Silberman, Judy Wrobel, Dr. Bill Marshall, Geraldine de Haas, Mary Ellen Perveiler, Vince and Rose Guccione, Mary Ellen Samuels, Betty Samuels, Hank and Faye Thomas, John and Urania Vusikas, Admiral Thomas Stansbury, Mary Morony, Phil Collins, JoAnn Apley, Tom Smusyn, Phil Roth, Josephine Artus, Russ Ricobene, David Ricobene, Nancy Basil, Clarence and Dorothea Palmer, and Antoinette Giancana. A special thank you to Bette Jean Sederling for your interest and support.

Also with special admiration, respect, and thanks to Brian Swift, who proves time and again that adversity is never an obstacle to achieving one's goals.

A heartfelt thank-you to my grandfather Emmanuel Jeswein, who was my favorite storyteller.

Finally, a special thank-you to Priscilla Finn, whose excitement, enthusiasm, and midnight phone calls are greatly missed.

INTRODUCTION

Present day South Shore appeared about 8,000 years ago as the glaciers retreated to form what eventually became present day Lake Michigan. The Native Americans and French found the area to be excellent for hunting and trapping. By 1855, South Shore was populated with German and Swedish farmers. Streets appeared by 1874, and by 1905 all of the streets, from Sixty-seventh to Eighty-third, and from the lake to the mainline of the Illinois Central, existed. The 1898 *Chicago Blue Book*, which was the social directory, listed 161 families represented by South Shore. The 1906 appearance of the South Shore Country Club solidified the notion of the area being genteel. In 1905, Lawrence Heyworth was president of the Chicago Athletic Club. He got the idea of having a country club in connection with the Athletic Club so members could enjoy all the amenities of a beautiful club in the country. The grounds where South Shore Country Club would eventually be built was a popular fishing spot where Heyworth would take his own children to fish. The property was purchased from Elisha W. Willard of Providence, Rhode Island, for the amount of $30,000 down and $245,000 in 24 years with interest at 4 percent on deferred payments.

Heyworth sent letters to members of the Chicago Athletic Club expressing his desire but received few acceptances. He then approached leading Chicago industrialists and prominent Chicagoans asking them to loan their names for the letterhead of his second letter. The results of the second letter brought over one thousand acceptances along with a $100 initiation fee.

The architectural firm of Marshall and Fox, who were responsible for the Drake Hotel, Blackstone Theatre, and Edgewater Beach Hotel, were hired. The club was a huge success and 10 years later the larger, current, main clubhouse was built.

The club prospered and became one of the most prestigious and most sought after memberships in Chicago. Events such as formal balls, holiday parties, cotillions, and social gatherings for all occasions became legendary. Golf, tennis, swimming, horseback riding, and lawn bowling were a few of the outdoor activities offered. Exquisite dinners, book reviews, travelogues, movies, and art fairs were also part of the scene. Famous figures and celebrities included many of Chicago's movers and shakers, as well as politicians, kings, queens, and movie stars. Prosperity remained through the 1950s, but by the 1960s the surrounding neighborhood was beginning to experience racial and economic change. The club's restrictive policies excluded Jews and African Americans, although it comprised an increasing percentage of the neighborhood population. By the 1970s membership dropped to the point where by 1974 it was obvious the club would be sold. After one last gala event, the Cotton Ball of July 13, 1974, it was turned over to the Chicago Park District. The Chicago Park District restored the main club house and some of the remaining buildings and grounds. The original club house, and eventually some of the other original buildings, was demolished. The South Shore Country Club is now open to the public and is considered to be the crown jewel of the Chicago Park system.

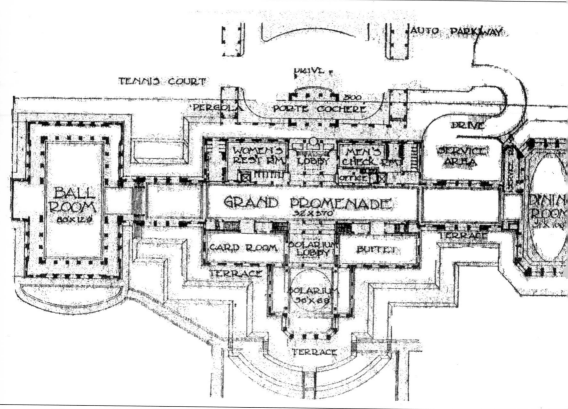

This is the floor plan of the 1916 South Shore Country Club main clubhouse.

One
IN THE BEGINNING

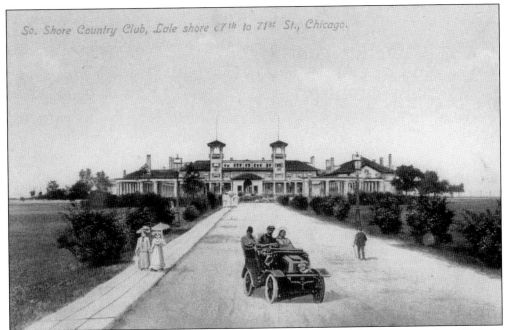

So. Shore Country Club, Lale shore 67th to 71st St., Chicago.

This vintage postcard shows the original South Shore Country Club as it appeared in 1906. At the time, the south lakefront was still considered to be "out in the country." Substantial homes were beginning to be built in South Shore and the nearby communities of Hyde Park and Kenwood already housed numerous wealthy families. Members arrived by horse and carriage or by automobile, which was considered by many to be a plaything of the rich. Everyday clothing was elegant and even more so for formal affairs. The early members were often Chicago's biggest and most well known names, and lived in downtown mansions, the Prairie Avenue district, Hyde Park, Kenwood, South Shore, and even a few North Shore suburbs. They came to the country club to enjoy their wealth and to mingle with others whose lives mirrored their own.

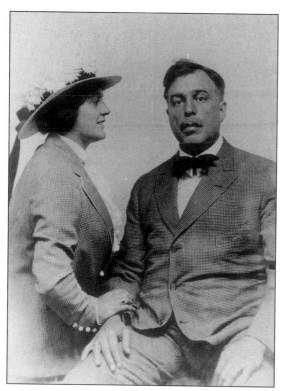

This 1915 portrait is of South Shore Country Club founder Lawrence Heyworth and wife Marguerite. In 1905, Heyworth, who was president of the Chicago Athletic Club, promoted the idea of having a country club in connection with the Athletic Club so that members could enjoy all the amenities of a beautiful club in the country.

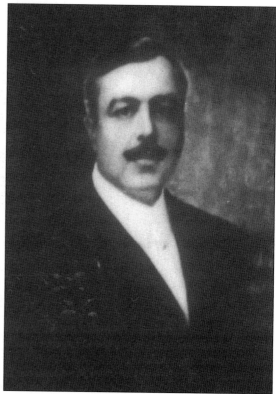

This Portrait of Lawrence Heyworth hung in the boardroom of the country club until its closing in 1974. It now resides in the home of Lawrence Heyworth III.

Marguerite Heyworth, shown here pregnant with Lawrence Heyworth Jr. in 1920, stands in front of the family home at 7651 South Shore Drive. This house, known as the Field-Pullman-Heyworth house, was originally located at what is now 5336 Hyde Park Boulevard in 1890. The house was relocated by barge on Lake Michigan in 1912 to 7716 Lake Avenue. The Lake Avenue property was sold to the city in 1917, and it incorporated the land into Rainbow Park. The house was moved just a few lots away to 7651 South Shore Drive where it remains today.

Pictured is Mrs. Marguerite Heyworth with her father, W.J. Kallscheuer, around 1915.

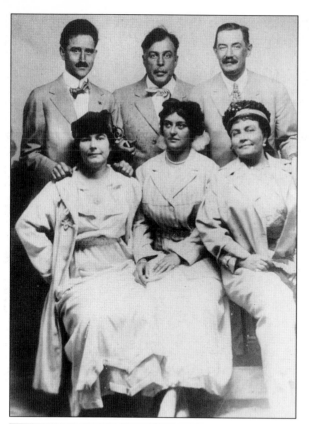

Lawrence Heyworth and his wife Marguerite (center) pose with two other unknown couples in this 1915 photo.

Marguerite Heyworth sits in a Woods Electric automobile around 1915. Mr. Heyworth's approved mode of travel was by way of Cadillac or Packard. At the time, horse-drawn carriages were being replaced by automobiles with names such as Auburn, Cadillac, Cord, Duesenberg, Pierce-Arrow, Packard, and Lincoln.

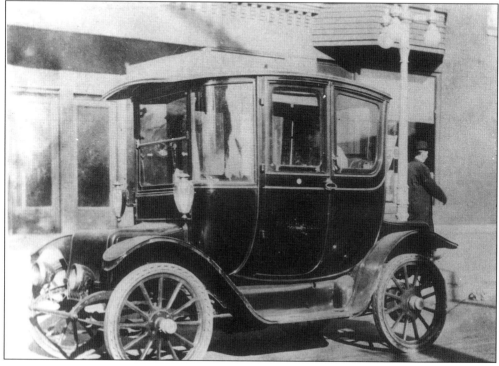

Mrs. Thomas A. Stevens and her guest are driven to the club in the high style of horse and carriage c. 1906. Annoyed when the Palmer House lost his dinner reservation, Mr. Stevens, a founding member of the South Shore Country Club, decided to give the Palmer House some competition by building the Stevens Hotel. Located on South Michigan Avenue, it was the largest hotel in the city at the time. It would later change hands to become the Conrad Hilton, and eventually the Chicago Hilton and Towers.

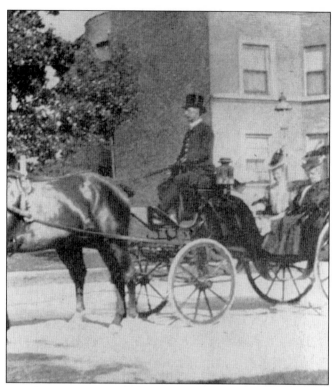

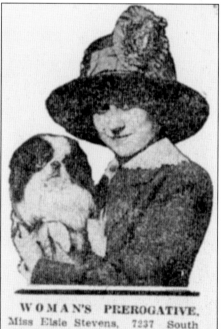

WOMAN'S PREROGATIVE.
Miss Elsie Stevens, 7237 South Shore drive, has changed her mind about a two months' Mediterranean cruise just twenty minutes before sailing time last Saturday.

Elsie Stevens, daughter of Thomas A. Stevens, may have changed her mind about a cruise, but she remained a loyal South Shore Country Club member until its closing. Miss Stevens, who later became Mrs. Stansbury, was active in the SSCC horse shows.

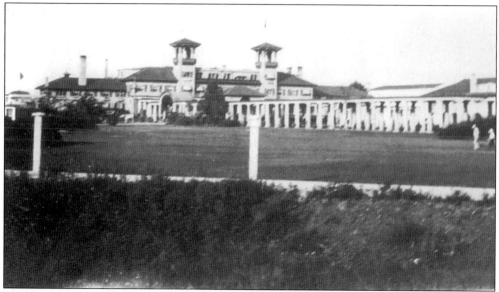

The original South Shore Country club is seen in this 1906 view. Despite threats of Hyde Park prohibitionists, the new club opened "wet" with 92 cases of champagne. In 1916, it was reported that 6 members spent more than $4,500 annually at the club, while 21 spent between $2,500 and $4,500 each year. Almost 200 of the club's members were in the habit of spending between $500 and $2,500 per annum.

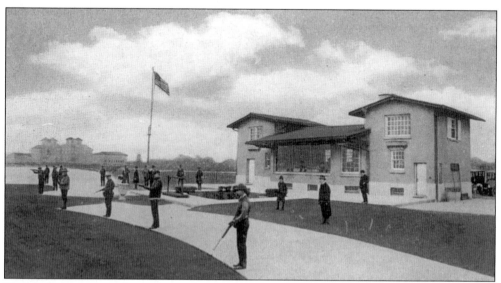

Here is the shooting lodge as depicted in an early postcard. Interior features included a fireplace, cathedral ceiling, and a large window that overlooked the lake. Designed by Marshall and Fox and built at the same time as the main buildings, preservationists and neighborhood residents were shocked when the 4,000 square foot building was unexpectedly demolished in February 1997.

This postcard from the early 1900s shows the original South Shore Country Club Ladies' Tea Room. There is no mention of the Ladies' Team Room being carried over to the second clubhouse.

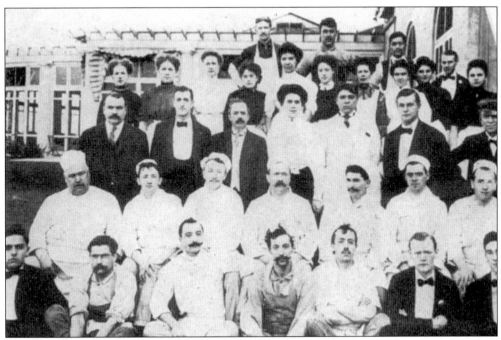

The 1908 dining room and kitchen staff are pictured in this photo. Front row, sixth from left, is Fred Henneberg, who was still with the club in 1948. Third row, second from left, is Frank Bruni, then headwaiter who went on to become head of dining room at Flossmoor Country Club. Second row, fourth from left, is Chef Kuntz.

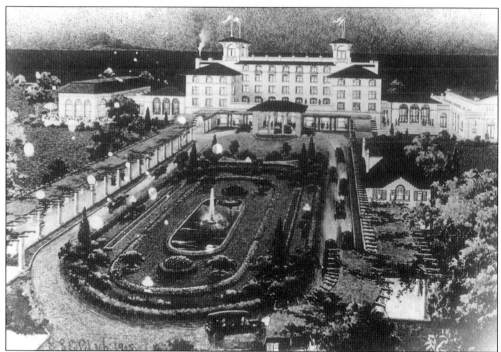

By 1913, the demands put upon the original club facilities at South Shore were greatly expanded. At this time, no new members would be admitted except in the event of resignation or death. It was decided that a new club building would be built in order to satisfy the needs of members. This 1915 artist's concept shows what the new buildings and grounds were to look like. The center fountain never materialized.

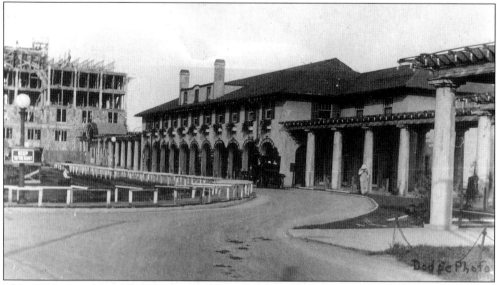

This 1915 view shows the new South Shore Country Club rising in the background. At the time the new building was under consideration, there were 1,827 members. When the new building was finished, the total value of the property was expected to be over $1,800,000. The corner stone of the new clubhouse was set October 9, 1915, and opened New Year's Eve, 1915.

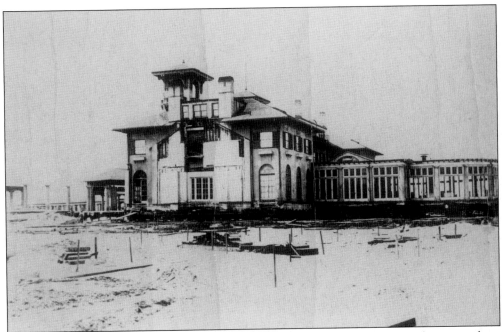

Pictured is the original clubhouse immediately after it was moved to its new location, along with an addition known as the "Bird Cage," which was added c. 1915. This move, slightly south of the current main clubhouse, was necessary in order to make room for the current Marshall and Fox building.

The south lakefront was still somewhat desolate in 1915 when the original clubhouse was moved in preparation for the new structure to be built.

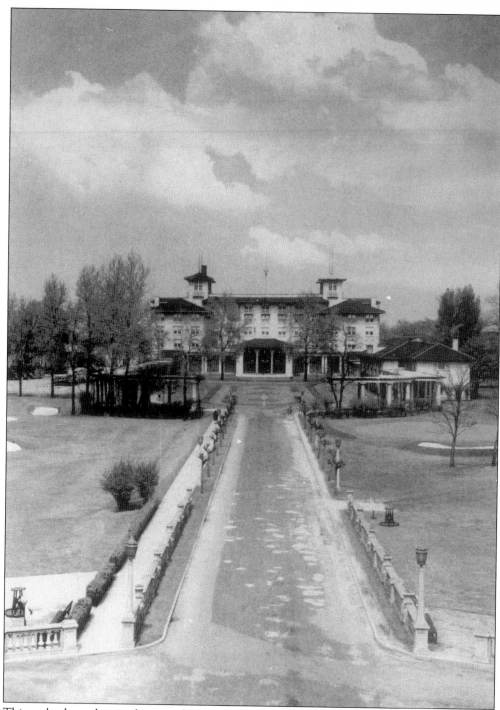

This early photo depicts the new clubhouse that opened New Year's Eve 1915. Club President Everett C. Brown made the conservative estimate that each of the 1,500 ladies attending the opening night gala wore a minimum of $600 in dress and jewels. He then went on to estimate the value of the clothes and jewels of the 1,500 men and felt that the combined value far exceeded $2 million.

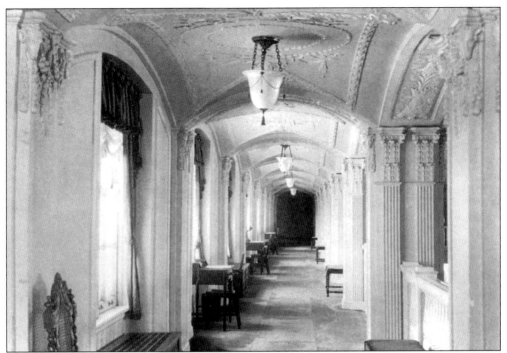

The photo above, taken in 1916, shows the new clubhouse second-floor hallway leading to the private residential rooms. Notice the intricate plaster reliefs featuring decorative ram heads.

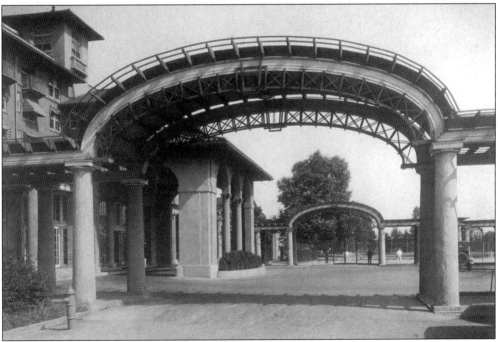

The port cochere to the left is where the doorman greeted members and guests before they entered the marble foyer of the clubhouse. Large, elaborate brass door handles were engraved with an intricate SSCC design.

In this early photo of the new main clubhouse, colonnades bank the wide drives and walks leading to the main entrance. On New Year's Eve 1915, 700 automobiles in blocks of 7 cars arrived and departed within two 90-minute intervals.

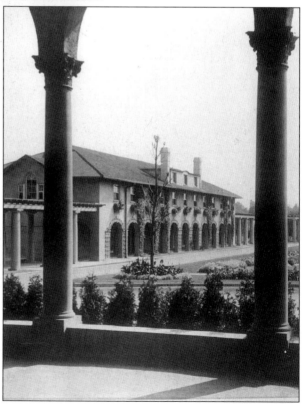

This early photo was taken from the portal looking west at the Casino Building (now demolished).

Here is a view from the Passaggio looking upwards toward one of the three magnificent chandeliers and the second floor balcony.

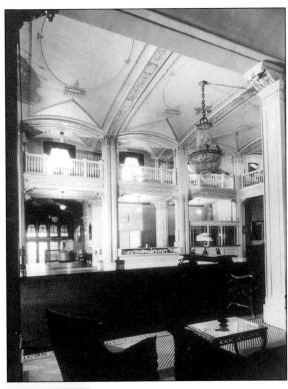

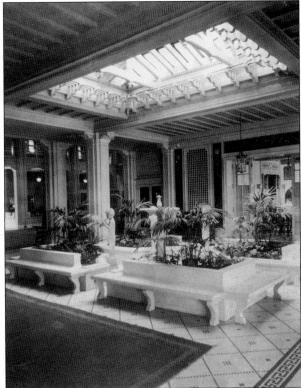

As seen in this early view of the entrance to the solarium, the skylight provided light for the palms and other tropical plants that were popular at the time.

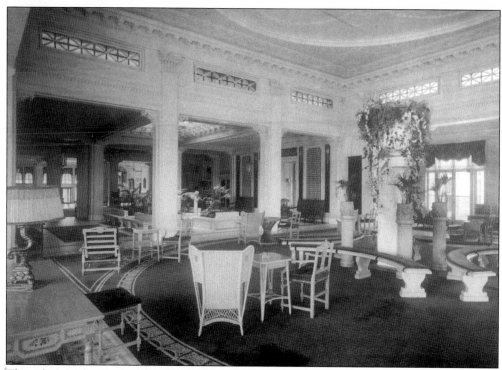

The solarium, facing the lake, featured an interplay of light and shadow.

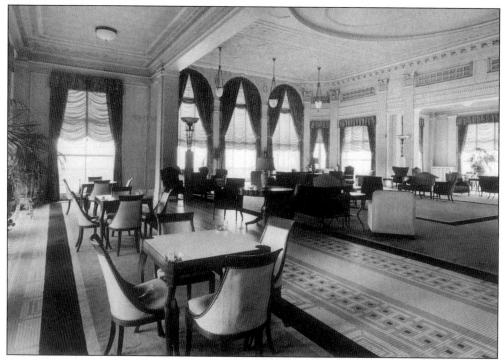

Another view of the solarium shows the intricately patterned tiled floor. The small, approximately 1-inch tile squares were set back in 1915 and remain in excellent condition today.

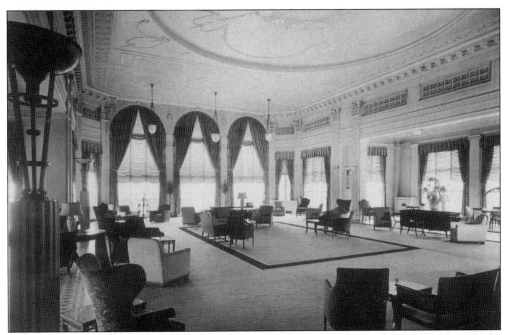

The large windows in the solarium, as well as those in the dining room, would easily open by lifting the large brass bars at the base of each window. This would allow the cool breezes to come in off the lake during the days before central air-conditioning became available.

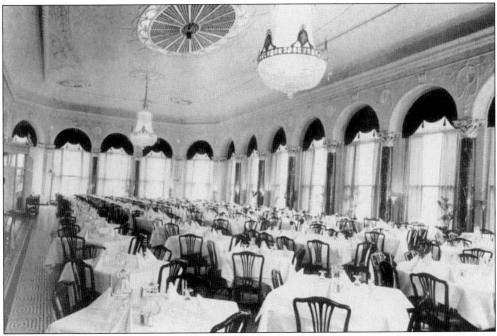

The main dining room, shown here in the 1920s, featured a Wedgwood scheme of pinks and rose colors accented with gold. The dark green faux marble pillars are striking against the pastels and the black and white patterned tile floor. This room is considered by many to be the most beautiful of the main building.

In addition to the grand public rooms, private suites were available to houseguests or as seasonal residences for members. Prominent actors performing at Drury Lane Theatre often stayed at the Country Club.

Actors Dick Powell and Joan Blondell spent a night at the club during their honeymoon. Bing Crosby and his family stayed in one of the guest apartments during the summer of 1966 while appearing at Drury Lane.

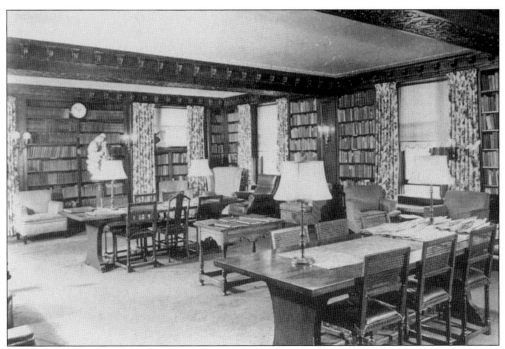

The club library offered a vast array of books on a variety of topics. Classics, the latest novels, monthly periodicals, and daily newspapers were available. A librarian was present to assist in locating a desired book, offer a suggestion, or engage in an informal review.

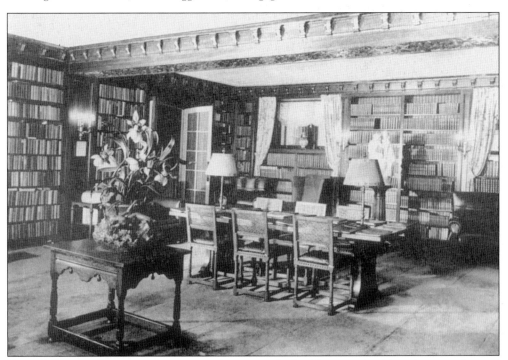

Beautifully carved beams and warm wood tones made the library an inviting place to relax and enjoy the peace and quiet. This view is from 1941.

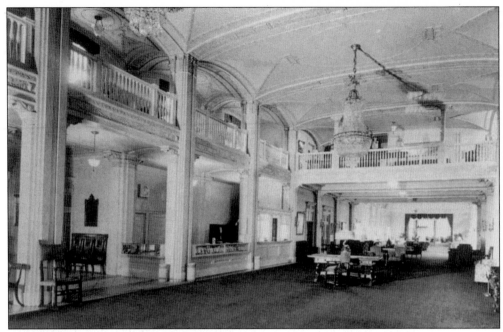

The Passaggio of the South Shore Country Club was conceived as a promenade to the grand ballroom and the main dining room. The expansiveness of the Passaggio is best realized by the fact that three different orchestras could be playing simultaneously in various parts of the clubhouse without interfering with each other.

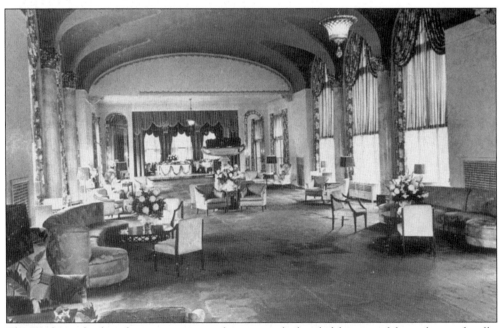

The Wedgwood color scheme accentuates the intricately detailed features of the ceiling and walls. The three enormous crystal chandeliers in the Passaggio remain today, as do those in the solarium, dining room and ballroom. The main clubhouse carpet and furnishings were changed and updated over the years, but the original plaster details, moldings, and chandeliers would remain unaltered.

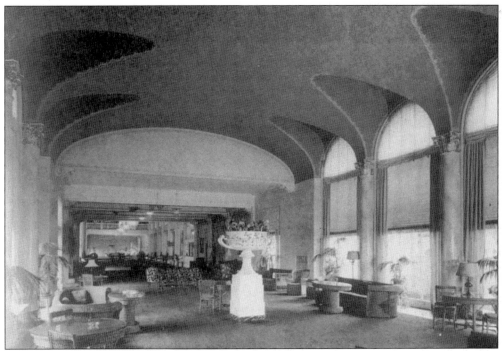

This view of the Passaggio looks north from the ballroom.

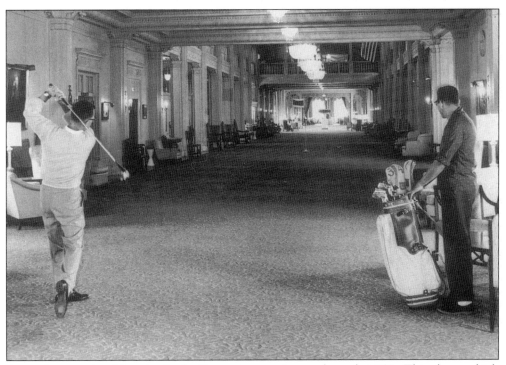

A member practices his swing in the Passaggio sometime in the early 1960s. This photo, which was most likely taken as a joke, does give some indication of the length and width of this beautiful area.

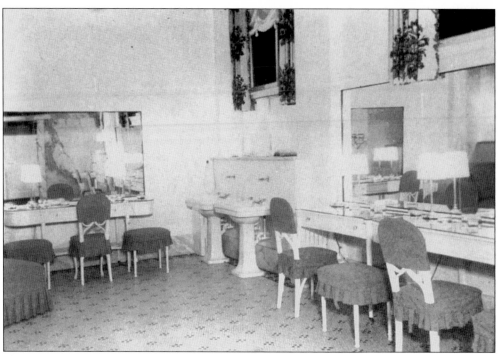

This 1944 view provides a glimpse of the ladies' room, where the women of South Shore Country Club made sure everything looked "just right."

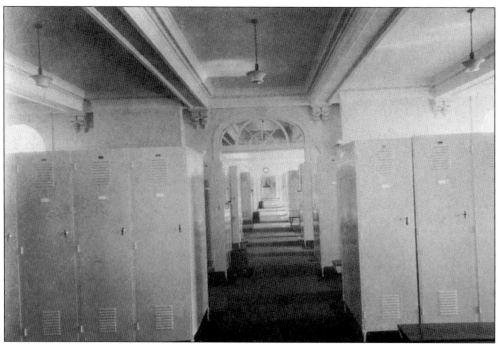

Just prior to the opening of the SSCC, the nearby Washington Park Club closed its doors. Lockers were purchased by the new club and installed in the men's locker room shown above. These lockers remained until the closing of the club in 1974.

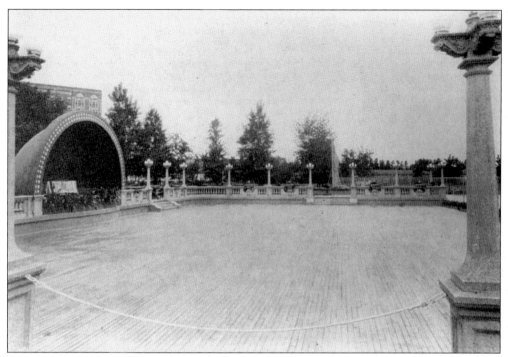

The outdoor dance pavilion and band shell opened July 4, 1920. On summer nights, music filled the air and neighbors living in nearby lakefront apartments were entertained.

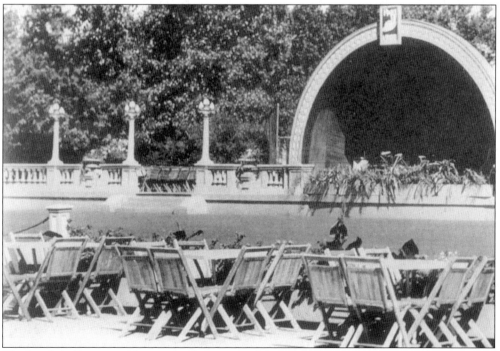

The band shell, pictured here around the time of the 1933 World's Fair, displayed the art deco logo of the event.

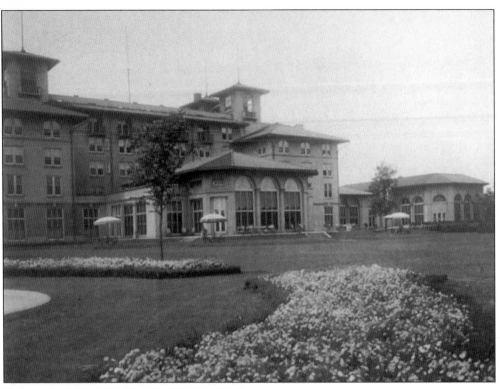

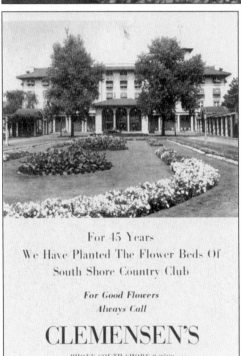

The lakeside lawn reached to the beach from the solarium at the center of the building. Umbrellas and lounge chairs dotted the landscape. Beds of flowers bloomed profusely, benefiting from the summer sun. This area was a retreat for those looking for peace and quiet in sun or shade while enjoying the view of Lake Michigan.

Here is an advertisement from the 1956 edition of the South Shore Country Club's Golden Anniversary magazine. Clemensen's, a local business, continued to plant the flowerbeds up to the time of the club's closing.

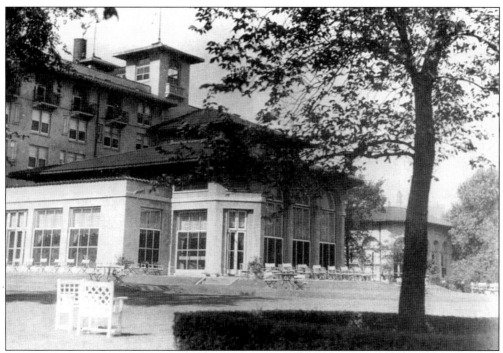

Floral plantings and trees highlighted the manicured grounds facing the lake.

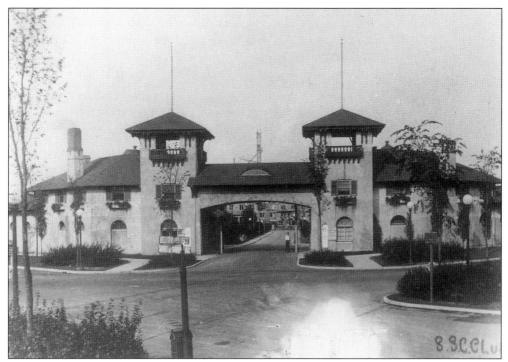

The imposing entrance of South Shore Country Club is seen here in 1915. The enormous gate, which effectively sealed off the entrance, became symbolic of the exclusive as well as restrictive aspects of the club. Notice the new main clubhouse rising in the background.

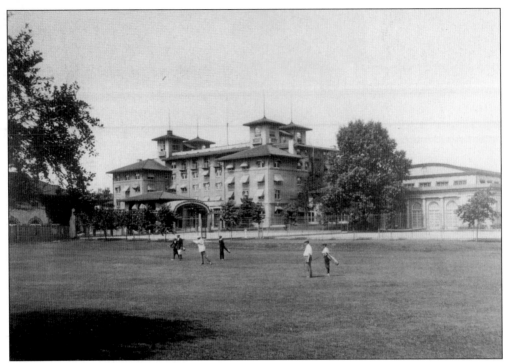

This is a view of the main clubhouse looking north from the green.

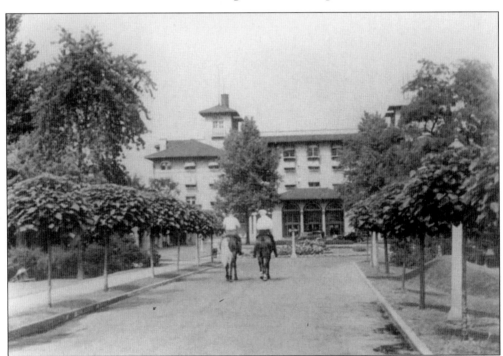

This early photo features two equestrians leisurely strolling toward the main entrance. Over the years the various trees and plantings have changed, but even today entering the grounds from South Shore Drive and approaching the main clubhouse is still an impressive sight to behold.

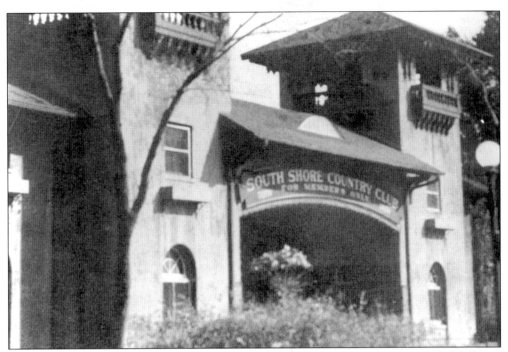

The stately entrance portals as shown in this 1941 photo were clearly symbolic of different things to different people. Directly behind the South Shore Country Club "For Members Only" sign was a gate that could be lowered if necessary, barring any admittance.

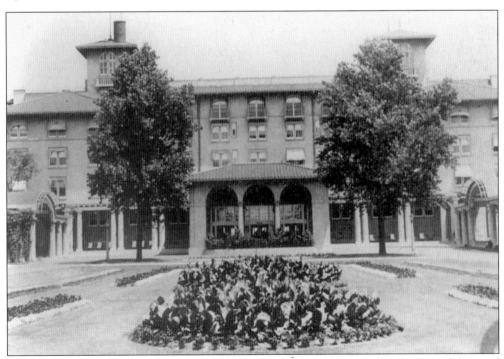

Summer plantings, particularly those leading to the main clubhouse, were always well designed and beautiful.

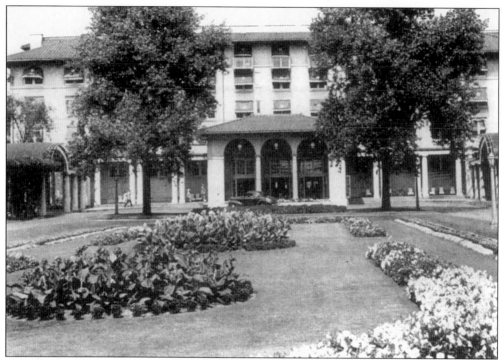

Seen here in the summer of 1947, the club buildings were an eggshell white color featuring green canvas awnings, each with a white tree logo in the center. When the club was eventually restored in the mid-1980s, it was painted a reddish terra cotta, the original color-scheme architects Marshall and Fox had intended.

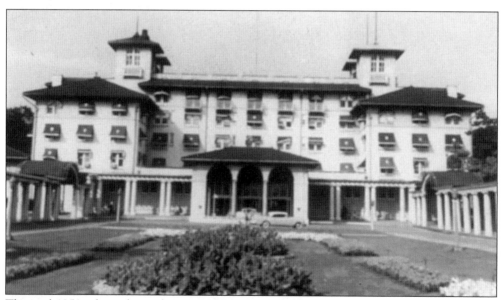

This mid-1950s photo shows the main clubhouse during a time that the South Shore Country Club was at its peak. Membership in 1956 reached 2,006. Memberships were at a premium and the waiting list long. By 1973 membership slipped to 731. During this final full year, the club's operations lost more than $177,000, despite an assessment that brought in $124,000.

34

Two
THE COUNTRY CLUB
SOCIAL SCENE

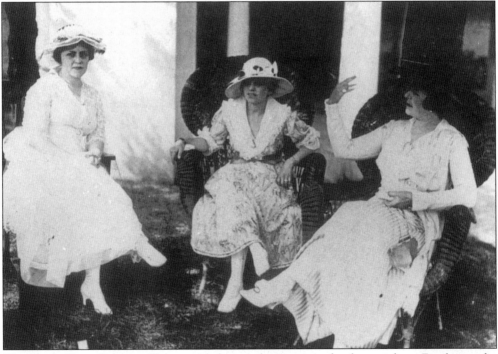

The South Shore Country Club provided an exclusive venue for the social set. Displaying the fashion of the times, this 1915 photo shows South Shore Country Club ladies seated with the original clubhouse behind them.

Examples of the wealth of the day can be seen in the following information from a 1910 bridge tournament. First prize was a sterling silver coffee set on a matching tray; second prize was a 3-inch bar pin with sapphires and pearls. In 1911, the choice of prizes included a gold leaf lamp with silk shade covered in gold lace, or a dozen sterling silver after-dinner cups with Royal Doulton cups to fit inside.

South Shore Country Club was known for its elegant balls, holiday parties, theme-oriented events, and exquisite dining. This photo from a Black and White Ball, so named because of the mandatory black and white formal attire, affords a glimpse of life at the club in the 1930s.

Mr. Franklin B. Evans, who in 1937 had just been elected president of South Shore Country Club, is seated with Mrs. Frederick C. Herendeen at the Back and White Ball.

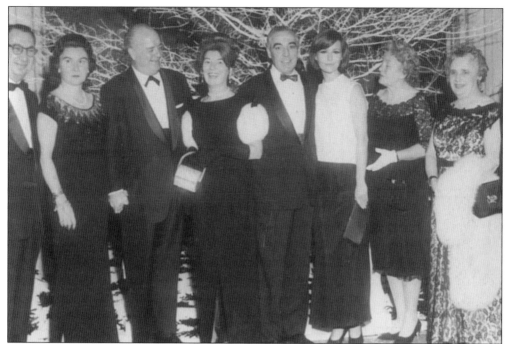

The Black and White Ball was one of the most favored and most elegant of the formal affairs. Attending this event in 1964 are Mr. and Mrs. George Albiez, President and Mrs. Finn, Robert Cusack, Miss Bonnie Ruemelin, Mrs. Floyd Dana, Mrs. Ernest Michaels, and Mr. Michaels.

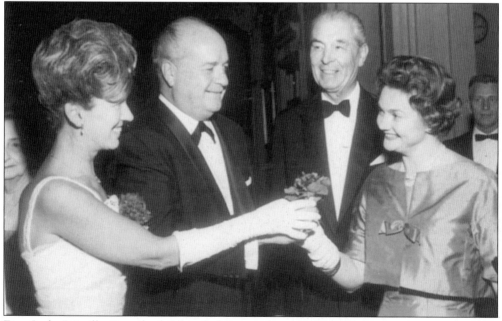

First Lady Priscilla Finn (at left) and club president Ambrose Finn, present a corsage to a visiting guest c. 1964. By the 1960s, it was becoming more difficult to enforce the dress code of previous years. There were still plenty of formal events where formal dress was expected, yet although the dress code was not relaxed, times were changing.

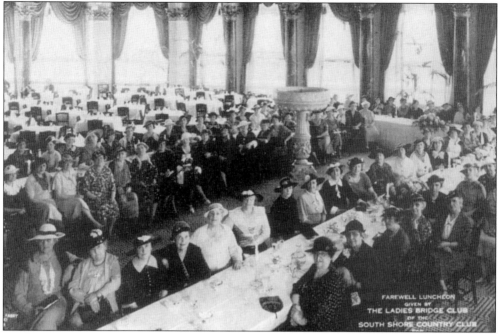

Captured here is the farewell luncheon given for Mrs. Charles E. Bartley in the main dining room of South Shore Country Club, 1935.

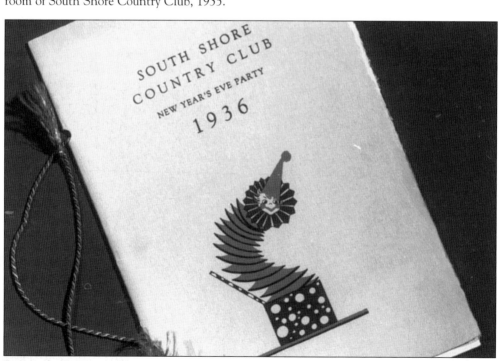

During the 1930s, most Americans were still feeling the effects of the Great Depression. Some former members have stated that there never seemed to be any shortages or noticeable changes during that era at the club. Here is the front cover of the South Shore Country Club New Year's Eve Party menu for 1936.

IMPORTED CHAMPAGNE				New Year's Eve Dinner
		Bottle	Half Bottle	
1 Lanson (Pere Fils) - 1926		7.00	4.00	Canape '37
2 Pol Roger (Dry Special) - 1926		7.00	4.00	
3 Clicquot (Yellow Label)		7.00	4.00	Celery Olives
4 Piper Heidsieck - Piper Brut - 1926		7.00		Salted Nuts and Jordan Almonds
5 Pommery & Greno - Nature - 1926		7.00		
6 Mumms Cordon Rouge - 1926		7.50		Clear Green Turtle, au Madere
7 Monopol (Heidsieck) - 1919		6.50		Cheese Sticks

DOMESTIC CHAMPAGNE

Beef Tenderloin Steak, Fresh Mushrooms Bearnaise

| 10 Cooks Imperial | | 4.00 | 2.25 | |

Tomato Florentine Derby Potatoes

IMPORTED BORDEAUX WINES

| 12 Haut Sauterne - Boshamer, Leon - 1928 | | 3.00 | 1.75 | Sylvester Salad |
| 13 Chateau Yquem - Boshamer, Leon - 1926 | | 4.50 | 2.50 | French Dressing |

IMPORTED BURGUNDY

Biscuit Glace, Success
Petit Four

| 100 Pommard - Boshamer, Leon - 1926 | | 4.00 | 2.25 | |
| 101 Gevrey Chambertin - Boshamer, Leon - 1926 | | 4.00 | 2.25 | |

Demi Tasse

Thursday, December 31, 1936

The menu for the 1936 New Year's Eve Party describes a dinner fit for the rich.

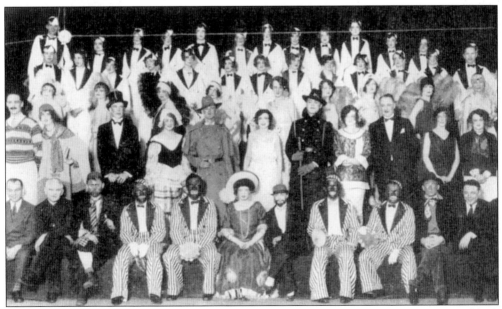

The South Shore Country Club Follies of 1926 featured some of the actors performing in black face. The yearly Follies featured performances by members.

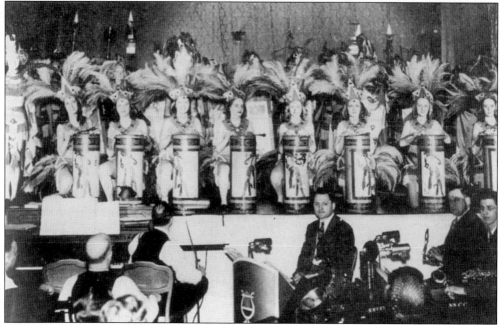

Elaborate costumes and headdresses are featured in this scene from the Follies of 1944. Professional wardrobes were used for the productions.

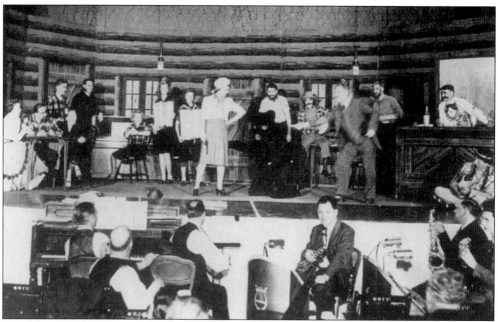

Nine hundred-fifty chairs were not enough to meet the demand for the South Shore Country Club 1944 Follies. Playing to capacity audiences on the evenings of Friday and Saturday, April 14 and 15, an additional 50 chairs were added to each night's performance.

Some of the girls from the 1944 South Shore Country Club Follies are seen singing "Mairzy Doats." This number was sung by Barbara Dorn and Joan Blosser, and danced by Alice Wolfe, Catherine Luce, Marion Dillon, Pat Casey, Jean Casey, Pat Cochran, Dorothy Folds, Mary Pat Zecher, Barbara Zegers, Jo Ann Green, Mary Lou Peterson, and Mary Ellen Swope.

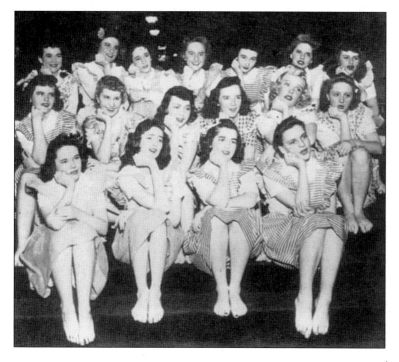

This scene from the 1944 South Shore Country Club Follies was from a number called "No Shoes." The Follies were a special event in which member talent could really shine. Costumes and acts could rival professionals, and no expense was spared in creating this yearly production.

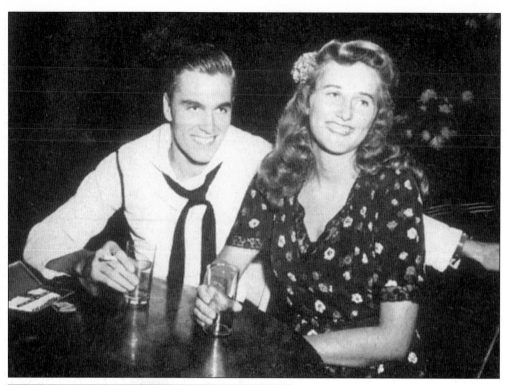

South Shore Country Club members lost a significant number of fathers, husbands, and sons during World War II. While on leave, Henry Moor Jr. and Joan Lillengren enjoy a 1944 summer evening in the outdoor pavilion.

OFFICE OF THE MAYOR

CITY OF CHICAGO

EDWARD J. KELLY
MAYOR

July 23, 1942

To the Members of the
South Shore Country Club:

It gives me real pleasure to convey this message of con-
gratulation to you who have made this fine project possible --
the Victory Issue of the South Shore Country Club Magazine. And
that means all of you -- the gallant men behind the guns, the
forward-looking members of America's second front -- the defense
plants, the loyal and steadfast workers in our various patriotic
organizations, as well as those of you who are doing your stint
by staying at home and saving at home to protect our country's
freedom.

You, who are truly representative of our staunch Middle
West tradition, are the people who have imparted to Chicago its
indomitable "I Will" spirit. That the Chicago area is unsurpassed
in filling its quotas of fighting men for our armed forces; in
its contributions through war industries and in bond and stamp
drives; and in the success of its all-out salvage programs, is
adequate proof that its native sons are made of the sterner sort
of stuff.

It is with a thrill of pride that I look upon the long
lists of men in active service contained within these pages, and
upon the great number of men and women who are doing not only
"their bit" but their utmost to bring us Victory.

It brings one a feeling of great satisfaction and confi-
dence to realize that all revenues accruing from this splendid
issue of the South Shore Country Club Magazine are being put to the
greatest possible service to our country -- that of buying United
States War Bonds. For so long as America keeps buying, Old Glory
will keep flying!

With cordial good wishes, I am

Sincerely yours,

Mayor

This is a letter dated July 23, 1942, from Chicago mayor Edward J. Kelly, sending his congratulations on the Victory Issue of the *South Shore Country Club* magazine. All revenues from this issue were used to buy U.S. war bonds.

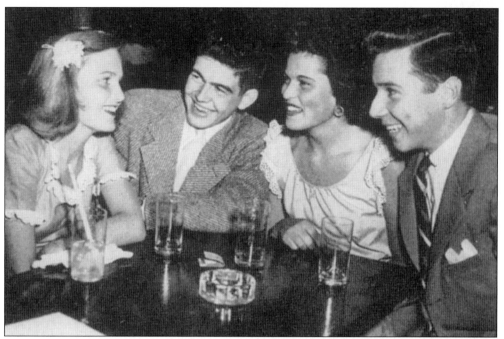

Jean Armstrong, Robert Mohr, Evelyn Dacey, and Robert Watson socialize together in 1944.

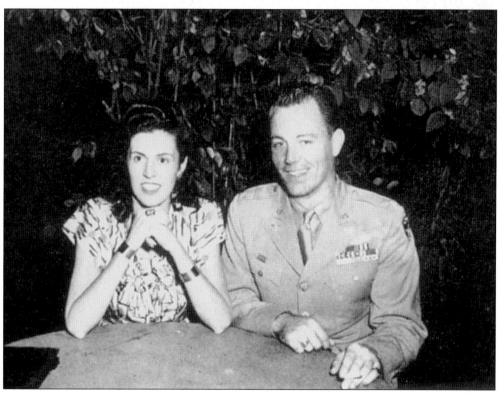

Another 1944 view shows Mary McGuire and Col. J. Hennebry enjoying a moment together at the club.

During the summer of 1944, Ray O'Donnell and Bobby Green enjoyed the cool breeze off the lake while dancing in the outdoor pavilion.

Carol Oakley and Bill Geer share a laugh while taking a break from the dance floor in this 1944 photo.

This June 1954 "TEEN-AGE" party was an opportunity for members' children and guests to mingle and have fun. Pictured here are the following: (top left) Margie Barry, Brian Jennings, Rich Harre, and Ellen Downs; (top right) Margie Wild and Frank Rogers; (below left) Bill Hohman and Mary Carol Daley; (below right) Sue Kuiper and Mike Madalon.

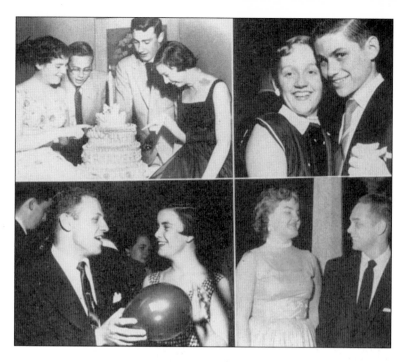

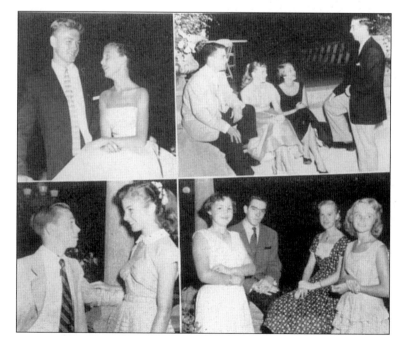

One of the "TEEN-AGE" parties in July 1954 included the following participants: (top left) Jay Precourt and Bobbie Jaeger; (top right) John Bycraft, Judy Nadherney, Pat Kinney, and Pat Crippin; (below left) Brian Jennings and Julie Juliano; (below right) Marsha Miller, John Cusack, Judy Callahan, and Diane Rogers.

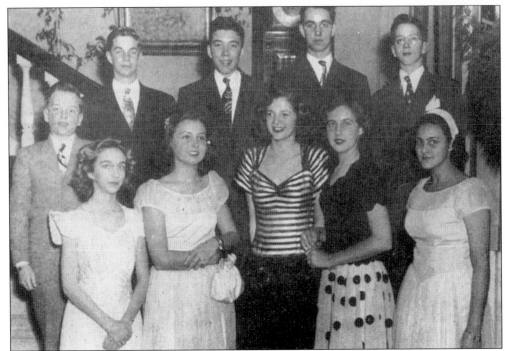

South Shore Country Club provided activities for every age group as seen in this 1944 Junior Christmas Ball. Pictured, from left to right, are: (front row) Martha Ann Underwood, Joyce Moynahan, Ann Herendeen, Mary Louise Moynahan, and Jacqueline Sciaky; (back row) Jack Ball, Morgan Underwood Jr., Albert Wrisley Jr., William Bibbs, and John Herendeen.

The stage in the grand ballroom is decorated for a Christmas show. The original 1906 grand ballroom was left intact when the new clubhouse was built. In 1926 a new innovation began called the Cabaret Supper and Dance. Members and guests came in the formal dress they had worn to the theatre earlier in the evening. An article states, "Herbie Mintz was there with his Master Musicians, and those nifty syncopators augmented a cabaret program highlighting the 'Charleston'."

A children's Christmas party in 1944 underscores the "family club" atmosphere at SSCC.

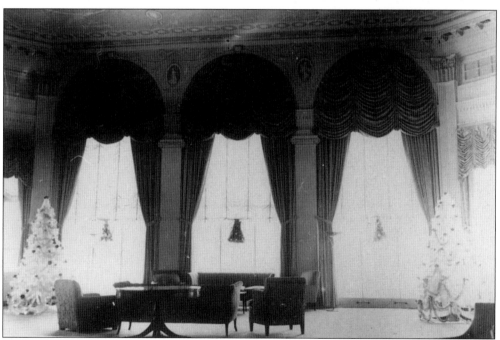

This Christmas photo was taken during the 1930s in the solarium. An original fixture from the original 1906 building still hangs in this room today. The ceiling features intricate reliefs of the zodiac. The solarium, which faces Lake Michigan, is usually bathed in sunlight. This room was used as a location for a scene in the movie A *League of Their Own* in which the character played by Madonna is practicing her etiquette.

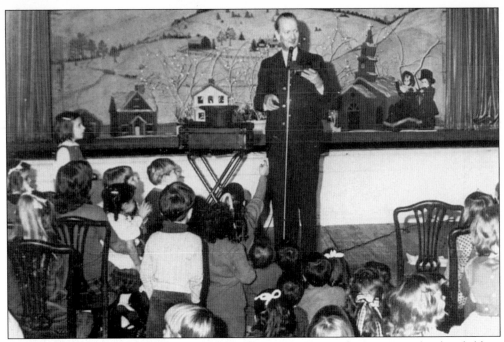

An attentive group attended this mid 1960s Christmas show and party given for the children of South Shore Country Club. The club was elaborately decorated with a beautifully decorated tree in the Passaggio by the main entrance.

Mrs. Pierre A. DeMets, of Pierre DeMets "Turtles" candy fame, enjoyed the 1967 children's Christmas party with Maria Carola Chrissis.

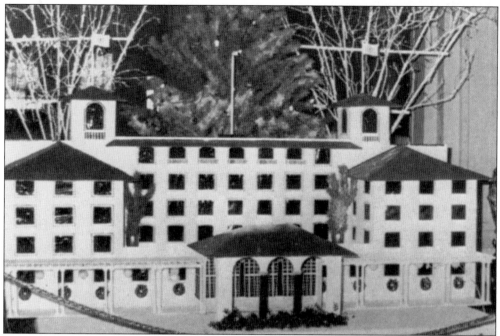

A young child stands next to a model of South Shore Country Club, part of the holiday decorations for Christmas 1965.

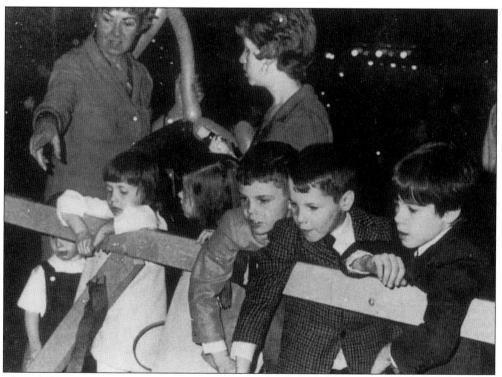

The Children's Christmas Party 1966 with Julie and Kelly Hansen on the left and Ricky Culbertson and Casey Dinges pictured at right.

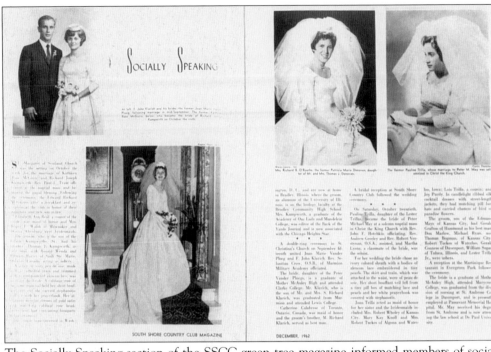

The Socially Speaking section of the SSCC green tree magazine informed members of social events. Much space was devoted to weddings, including the specifics regarding church, decorations, attire, receptions, honeymoon destinations, and residence. Also addressed were topics relating to vacation plans, summer residences, lectures, and visiting guests.

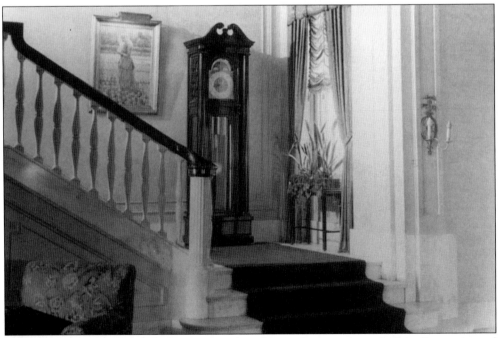

Countless brides descended this staircase or the other at the opposite end of the Passaggio, and paused in front of the majestic grandfather clock for photos.

Seen here in their February 1946 wedding picture are Lt. and Mrs. George R. Wendt, the former Loretta Howard. The Wendt's son George would go on to fame on the hit TV series *Cheers*.

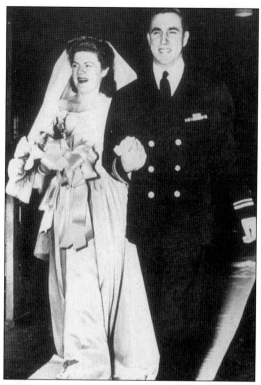

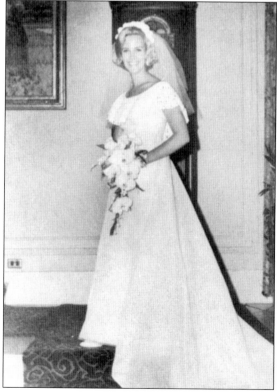

Many generations of brides posed by the grandfather clock at the base of the staircase. The former Mary Elizabeth Bax, bride of Kevin Moonan, is seen in this 1967 photo.

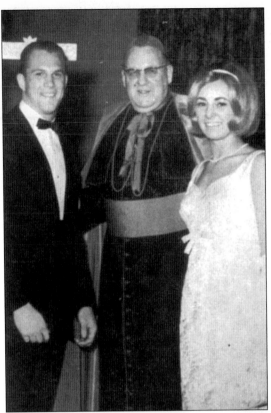

As the Irish-Catholic population grew in South Shore after World War II, it was reflected in the membership of the once heavily Protestant South Shore Country Club. It was not uncommon to see priests and nuns visiting as member's guests. Here John Cardinal Cody visits with Rick Anderson and Carol Ann Lewis, who announced their engagement at this 1967 Presentation Ball.

South Shore Country Club was a club where generations of families could often be seen. During the club's peak years in the mid 1950s, memberships were at a premium and waiting lists long. Memberships were passed down from generation to generation and openings were few. Within 10 years this would change drastically and current members were encouraged to bring in new members.

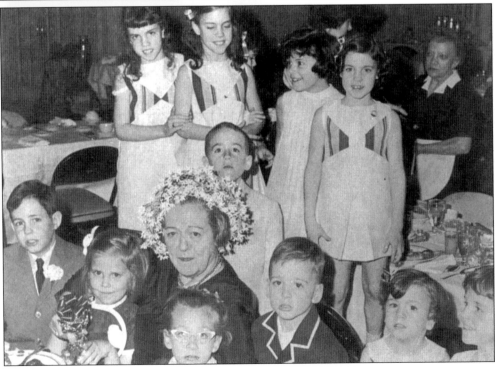

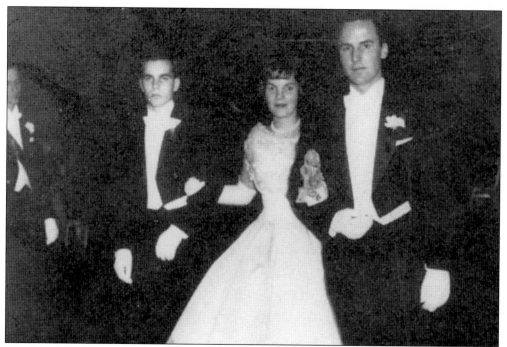

The future mayor of Chicago, Richard M. Daley (at left), escorts his sister Eleanor at a debutante Presentation Ball in 1960 with Bob Calvin at right.

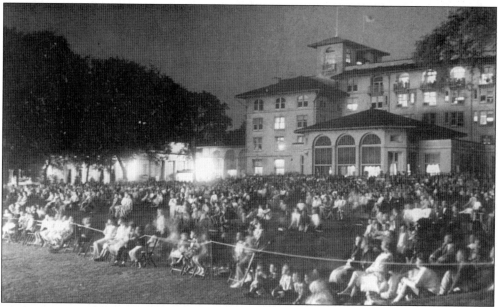

The Fourth of July firework displays were enjoyed by all; even non-members who lived in the area could delight in the sky show. In this 1960s photo, members relax on the lawn facing the lake while others watch from the balconies of their private rooms.

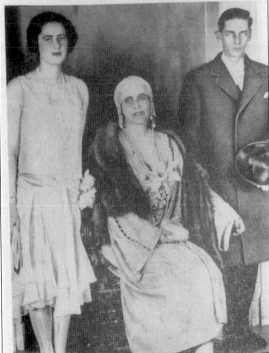

Queen Marie of Roumania with Princess Ileana and Prince Nicholas were guests at club luncheon in 1926. Their host, Charles J. Vopicka Minister to Roumania during World War I.

It was not uncommon for visiting dignitaries, royalty, or Hollywood celebrities to visit South Shore Country Club. Pictured here is Queen Marie of Romania with Princess Ileana and Prince Nicholas, who were guests in 1926. Their host, Charles J. Vopicka, was Minister to Romania during World War I.

Claire Windsor, star of the silent film era, visited the club with her friend Mrs. James E. Baggot Jr. In 1931, Jean Harlow visited South Shore Country Club as a guest of member Paul H. Jones.

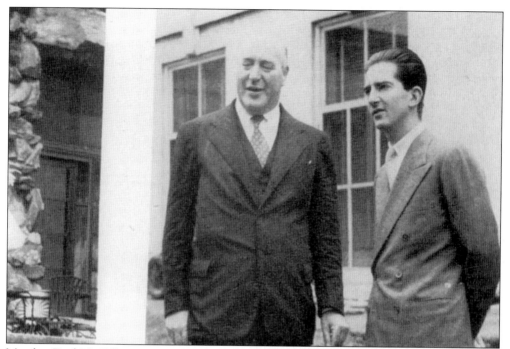

Member Fred M. Gillies visits with his luncheon guest, King Peter of Yugoslavia.

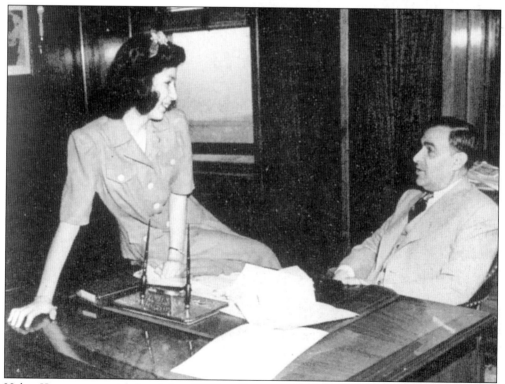

Helen Karzas poses with her father William Karzas in 1942. William Karzas was the owner of the Trianon and Aragon Ballrooms.

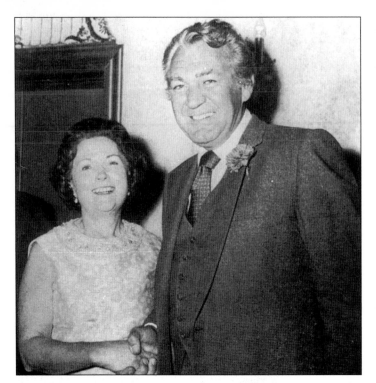

Actor Forrest Tucker, who frequently appeared in plays at Drury Lane Theatre, was also a guest at South Shore Country Club. This 1970 photo features him with Mrs. Thomas J. Carroll.

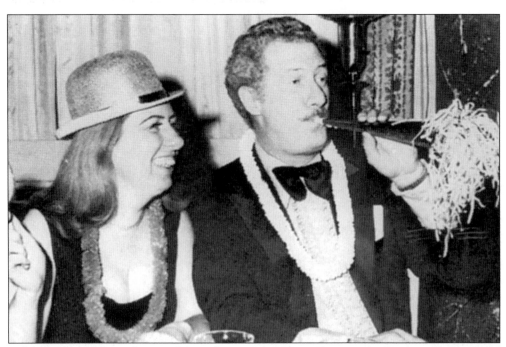

Ralph Foody and his wife Jan celebrated New Year's Eve 1971 in style. Foody, a distinguished character actor and South Shore Country Club member, appeared in over 40 films and had countless television and live theatre parts. Among Ralph Foody's guests at the club were actress Jane Russell and actor Van Johnson.

Foody is well remembered for his role as the gangster tough in *Home Alone* I and II, as well as his role as a dispatcher in the movie *The Blue Brothers*. Pictured here in a 1973 photo, Foody plays Inspector Levine in the mystery/comedy *Catch Me If You Can* at Drury Lane Theatre.

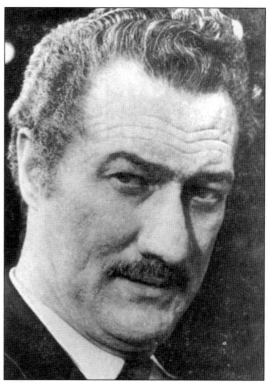

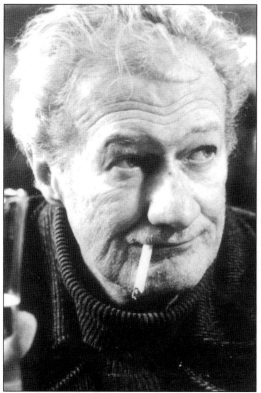

Here again is Ralph Foody as he appeared in a scene from a 1990 British film called *Cold Justice*. Foody attributed his stage and screen success to his looks and voice, which he characterized as "strictly Chicago."

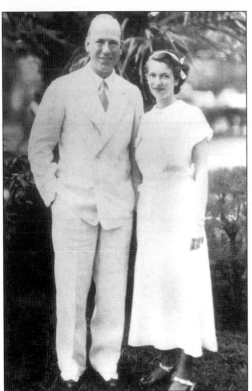

Mr. and Mrs. Charles Walgreen Jr. appear in this 1937 photo. The Walgreen chain of drug stores would eventually become one of the largest in the U.S.

Mrs. Henry Hafer, Mrs. Richard J. Daley, and Mrs. Joseph J. Hackett appear at a cocktail party honoring Mayor and Mrs. Daley in 1966.

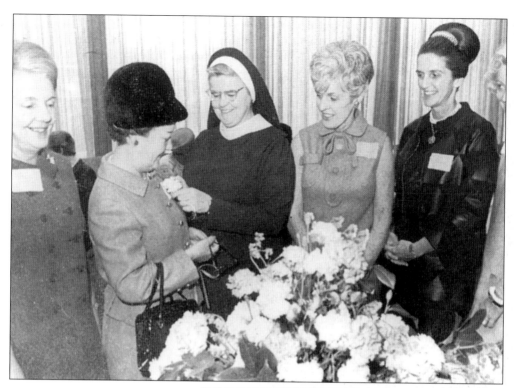

Mrs. Richard J. Daley receives a corsage at this South Shore Country Club luncheon. Pictured are Mrs. Thomas Leahy, Mrs. Richard J. Daley, Sister Mary Gwendolyn, RSM, Mrs. John Henebry, Mrs. John Dwyer Jr., and Mrs. Charles Murphy Jr. This spring 1968 St. Patrick membership tea was sponsored by Mercy Hospital Women's Board.

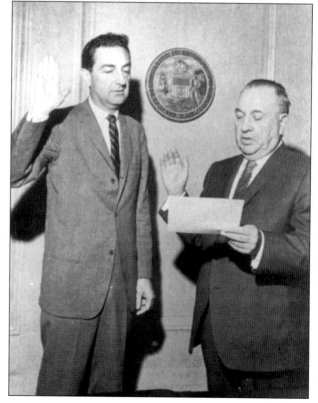

In an undated photo, club member Leonard F. Miska is pictured being sworn in as Commissioner of Human Relations for the City of Chicago by Mayor Richard J. Daley.

61

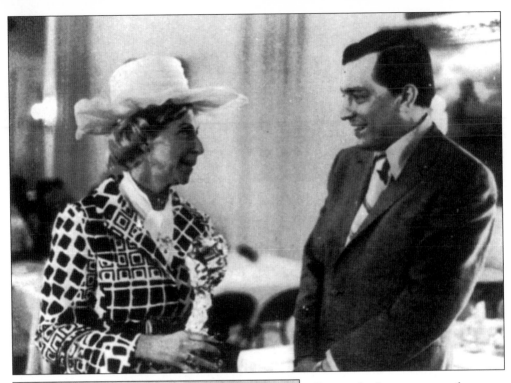

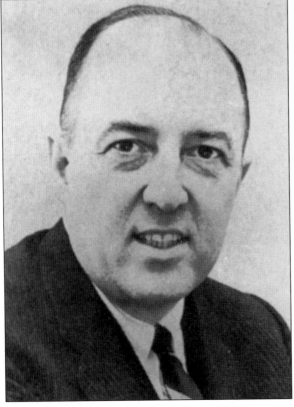

For nearly three-quarters of a century South Shore Country Club was a favorite destination for Chicago's politicians. Mrs. Frank Padour is pictured discussing Chicago politics with Judge Edward Vrdolyak in this 1970 photo. Mayor William Hale Thompson, better known as "Big Bill," was a member of the club.

Emmett Dedmon, editor of the *Chicago Sun-Times*, was a long time South Shore Country Club member.

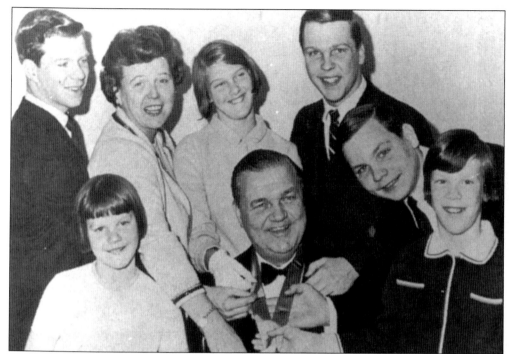

Former Secretary of State Michael Howlett and family pose for the camera in 1968 while admiring a medal presented to Howlett by the Minister of Israel.

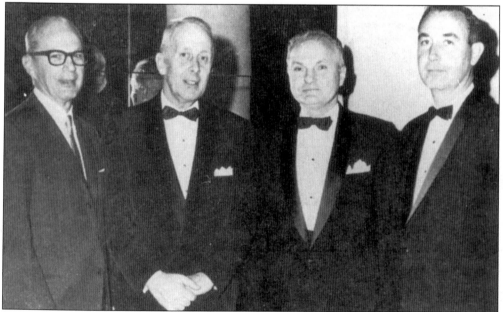

Club officers pose for a portrait in 1966. Pictured left to right are Joseph B. Fitzer, treasurer; Robert D. Fitch, vice president; Aubrey O. Cookman, president; and Edward M. O'Rourke, secretary. From the mid-1960s onward, club officers were beginning to be forced to face club issues pertaining to membership, finance, and eventually the disbanding and sale of the property. As each year progressed, the issues became more intense and difficult to resolve.

Mr. and Mrs. Arthur Kinsman and Charles Leary join in an impromptu song. Once, when Johnny Weismuller, star of the original Tarzan movies, was imbibing with friends at the bar he was prodded to give a sample of his famous Tarzan call. It is said that his Tarzan call was heard not only in the bar but through the entire Passaggio as well.

The Gaslight Girls give pointers to participants learning the latest steps in this late '60s photo.

Mr. and Mrs. Phil Collins and the John Hinkamps enjoy the festivities at the 1967 St. Patrick's Day Party.

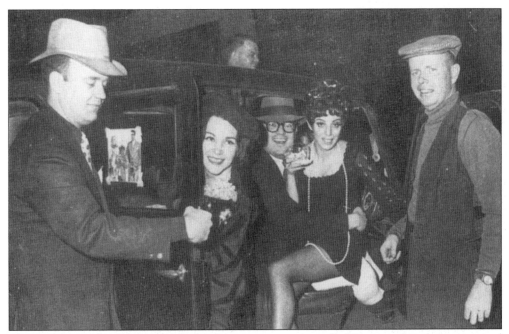

Theme party nights were not only fun but imaginative as well. Here a group of gangsters and their flappers enjoy an evening of 1920s era excitement. This Bonnie and Clyde Night was held Saturday, March 23, 1968. Pictured are Dick Sinnott, Donna Riordan, Dick Phelan, Jeff Barry, Carole Gattone, and John Nyhan.

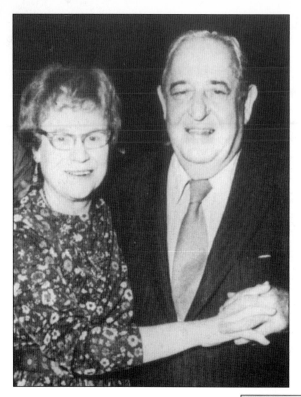

Lifelong members Mr. and Mrs. Chris Cheevers take to the dance floor in 1972. Grace Cheevers' father, William Plunkett, was an early member and Grace remained a member until the end. Grace was also responsible for the continuation of the annual South Shore Country Club Christmas Green Tree Ball, which moved to the Drake Hotel after the demise of the club.

During the 1960s, attempts were made to host events that would attract the younger members. As membership in general continued to decline, it became increasingly difficult to recruit new, younger members and to keep current membership. Some younger people viewed the country club scene as being stodgy, elitist, and "establishment." As the Vietnam War raged on, black tie affairs and formal balls began to be viewed differently by some of the younger people. Less formal and better-equipped health clubs were also becoming more popular. This March 1967 announcement was geared toward the under-40 crowd.

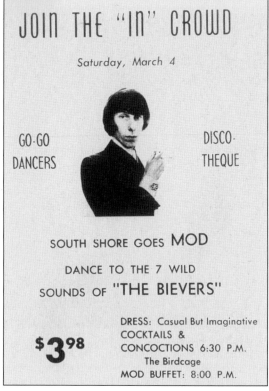

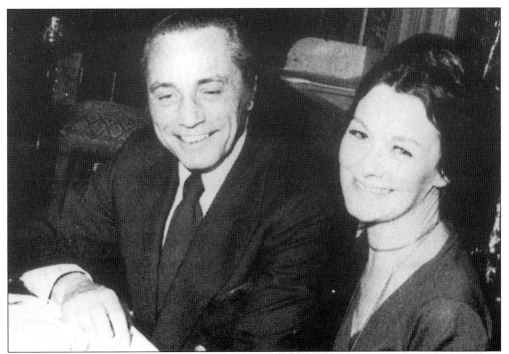

Pictured are Mr. and Mrs. Charles Apley enjoying an evening of dinner and dancing 1972.

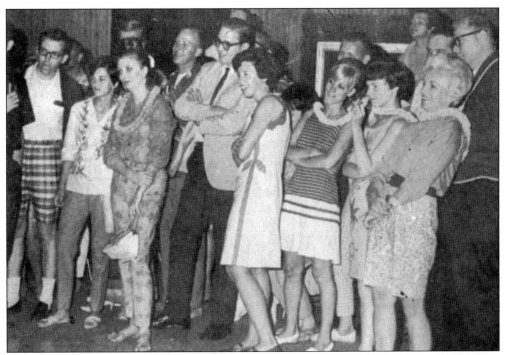

An appreciative audience enjoys watching fellow members try the limbo in this 1967 photo taken at the SSCC Jamaica Party.

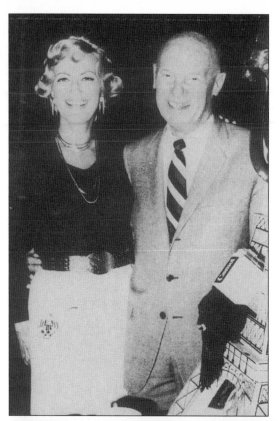

South Shore Country Club's final president George Craig and wife Jayne enjoy a festive evening. Being the final president of the club was like being the captain of a sinking ship. By this time, most members knew that the closing and sale of the club was inevitable, but facing this end was a painful task for many members whose affiliation and membership spanned generations.

The officers for the final operating years of the club are pictured here. These gentlemen knew they would be faced with the task of closing the club. For several years before it actually closed, there were plans being made for what many members felt would be the inevitable. Pictured left to right are Jerome Kutak, secretary; Thomas Reger, treasurer; George Craig, president; and Ellsworth Horsley, vice president.

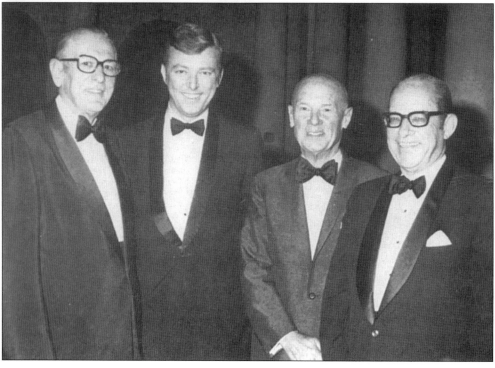

Three

RECREATION AT THE COUNTRY CLUB

South Shore Trees

I'd give the world if I could see,
A tree before I leave the tee;
The tee where all my shots are pressed,
The tree wherein my golf balls nest;
This picture proves conclusively,
How hard it is to miss a tree.

I see the fairway stretching far,
I dream a golfer's dream of par;
I swing my club so easily,
The golf ball starts, I shout with glee;
Good scores are made quite frequently,
But not by me—I make a tree!

–F.H.

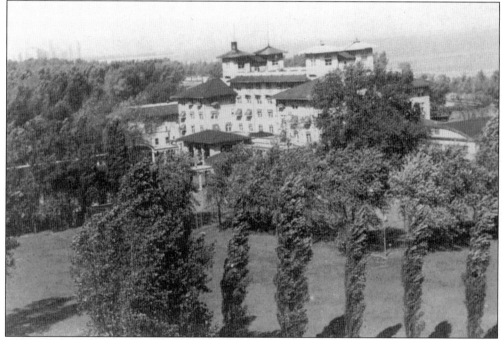

Although golf was a very popular sport at South Shore Country Club, there was a wide range of outdoor activities that members could enjoy. Sun bathing, boating, swimming, beach games, horse-back riding, horse shows, tennis, lawn bowling, and skeet shooting were offered and experts were available to provide lessons. At one time a toboggan shoot existed on the property.

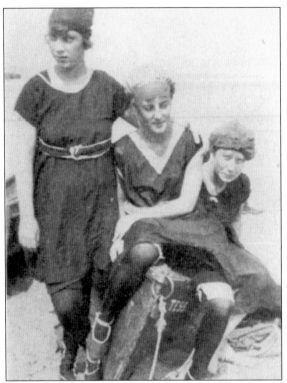

Mrs. Josephine Hubbard Snowberg, Mrs. Josephine Bulkley Johnson, and Mrs. Ethel Goodnow Vickrey show off their new bathing attire at South Shore Country Club beach, 1911.

Two unknown ladies enjoy the sun and sand during the summer of 1915. South Shore Country Club provided a private beach for members.

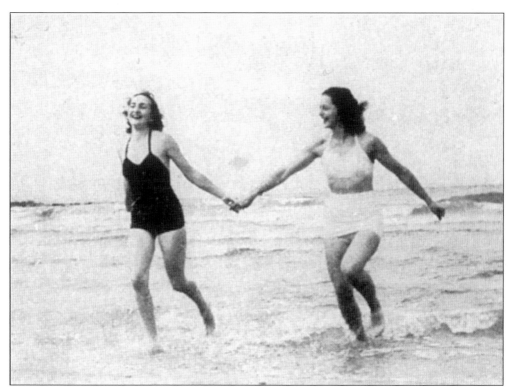

Mrs. John Mahoney and Mrs. Jackson Rowland enjoying the beach.

Mary Morony and nurse Mildred Lager are pictured at South Shore Country Club beach, 1942.

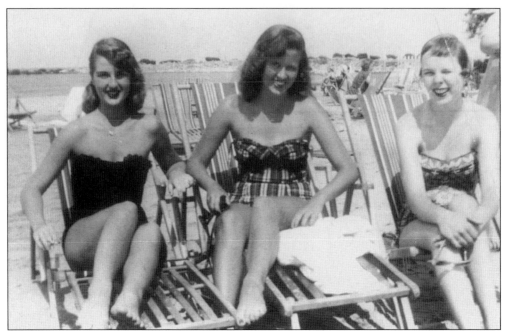

Posing on the South Shore Country Club beach in 1953 are, from left to right, Sally Knowles, Mary Morony, and Nancy Hoffman.

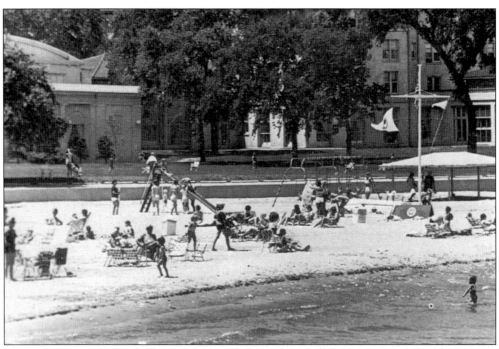

Many generations of South Shore Country Club members frolicked on its sandy beach. Privacy, supervision for young children, a roomy bathhouse, and a well-stocked refreshment stand enhanced a day spent on the beach.

The beach house was a great place to prepare for or cool down from a day of fun in the sun. This building was demolished shortly after being acquired by the Chicago Park District.

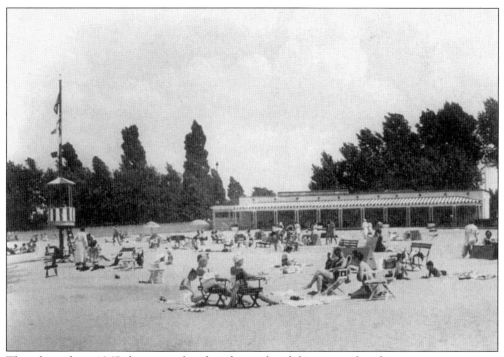

This photo from 1967 shows another fine day at the club's private beach.

A 1968 photo shows a late summer day in front of the beach house at South Shore Country Club.

Youngsters enjoying a day at the beach in 1968.

This cover of a program from an early Club Horse Show illustrates a female rider dressed in the latest equestrian fashion of the day. The 1913 show awarded prizes of $50–$75 for first place events and $25 for second place events.

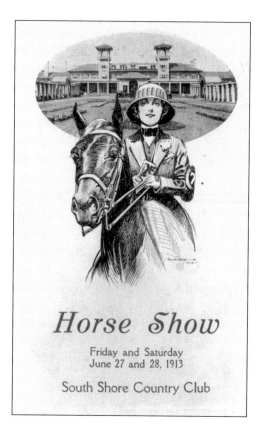

Horse Show

Friday and Saturday
June 27 and 28, 1913

South Shore Country Club

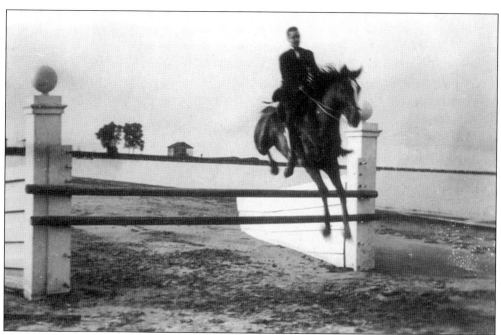

In this early photo a rider practices for a South Shore Country Club Horse Show.

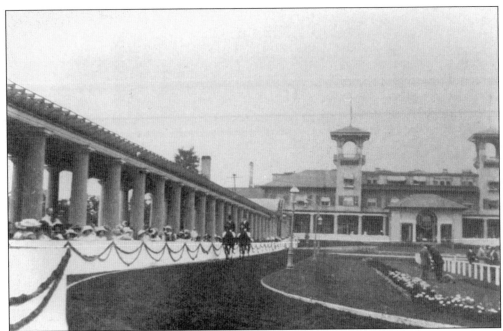

Before a formal ring was built, horse shows were presented on the grounds in front of the club. The cover of the program for the South Shore Country Club's 54th Annual Horse Show, held on Saturday, June 15, 1963, featured this photograph, taken 50 years earlier in 1913.

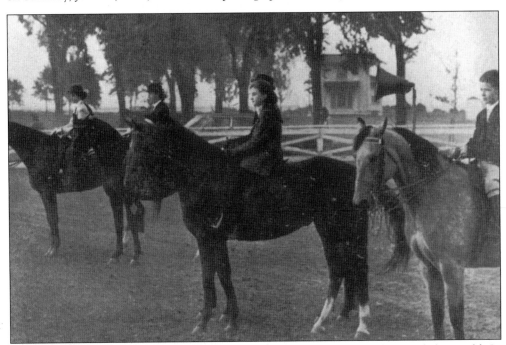

Horse shows were very formal events at the club and were recognized around the world. In 1963, the Spanish Riding School under the patronage of Mrs. John F. Kennedy and His Excellency Dr. Wilfred Platzen, the Austrian Ambassador to the U.S., began their tour of America at South Shore Country Club.

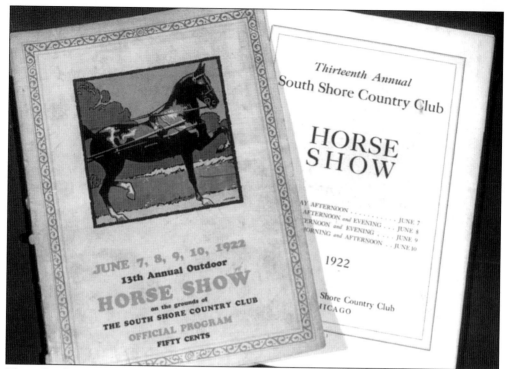

This official program for the South Shore Country Club 1922 Horse Show included extensive advertising and an explanation of the events, with a listing of their scheduled times. The list of exhibitors, along with their home address, contained many prominent Chicago names. Rules and regulations, with very precise expectations for the horse as well as the exhibitor, were also included.

Lehmann O. W., Lake Villa, Ill...
2, 3, 5, 6, 7, 8, 9, 11, 12, 13, 14, 15, 31, 32, 34, 35, 37, 38, 39, 40, 41, 43, 45, 53, 54, 55, 56, 57, 58, 59, 60, 61, 62, 63, 64, 65, 67, 69, 70, 72

Leopold, F. N., 4754 Greenwood Ave., Chicago, Ill..................... 25

Lewis, W. L., Tulsa, Okla....3, 4, 7, 9, 12, 17, 18, 19, 20, 21, 22, 46, 47, 49, 52

M

Marks, H. M., 337 South Franklin St., Chicago, Ill...................64, 67

Matthiessen, F. W., Trimfo, Cal...................................19, 20

Mayer, Elias, 5625 Woodlawn Ave., Chicago, Ill...............19, 20, 22
........24, 25

A partial listing of participants for the 1922 horse show includes an entry for *Leopold, F.N. 4754 Greenwood*. Nathan F. Leopold, along with his friend Richard Loeb, would become infamous two years later for the murder of a neighbor's son, Bobby Franks. Clarence Darrow defended these two young men in the case that would later be called "The Crime of the Century." Hal Higdon, a South Shore Country Club member, authored a book by the same name. Leopold and Loeb lived north of South Shore in the exclusive Kenwood area of Chicago. The exact point at which Jews became restricted is unknown. Leopold was Jewish, as were other members and guests, including Julius Rosenwald and his wife.

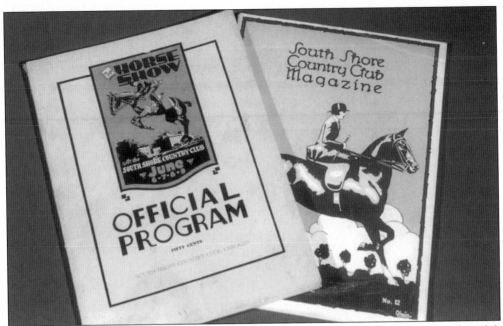

A program for the South Shore Country Club 1925 Horse Show is pictured along with a club magazine of the period.

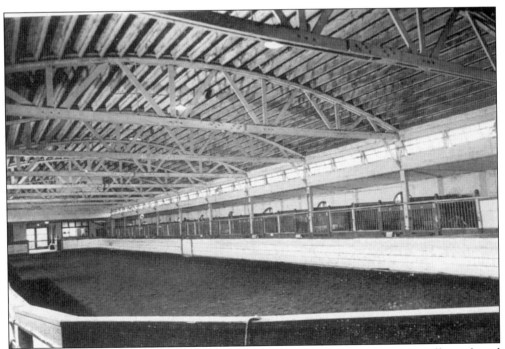

Many prominent horse shows took place in this indoor riding arena. The arena still stands and currently houses horses used by the Chicago Police Department.

In this early photo a horse and rider jump a hurdle. The club's three-day horse shows were world-famous. Each year, member George Getz brought two donkeys and two camels—named Hamad and Sada—from his Michigan farm for the amusement of children and adults alike. When one of the camels died during the show, its skeleton went to the Field Museum.

A 1948 photo shows Henry P. Conkey, a sponsor of a Hackney Poney Class for the horse show in that year.

Lois, Thomas, and Elsie Stansbury won the 1948 Family Class award.

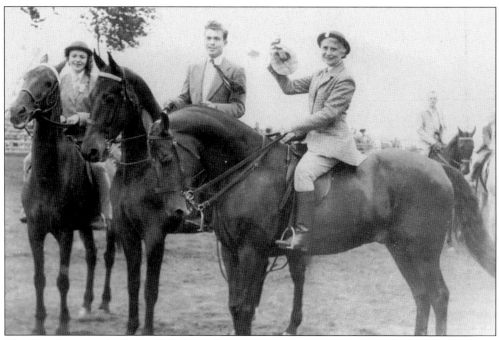

The Stansbury family show off their trophy.

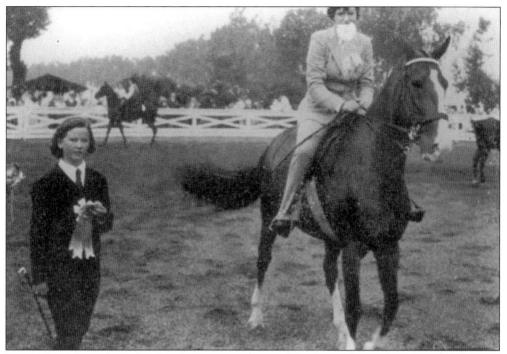

In another photo from the South Shore Country Club Horse Show of 1948, Mary Morony awards a prize to May Kay Starshak.

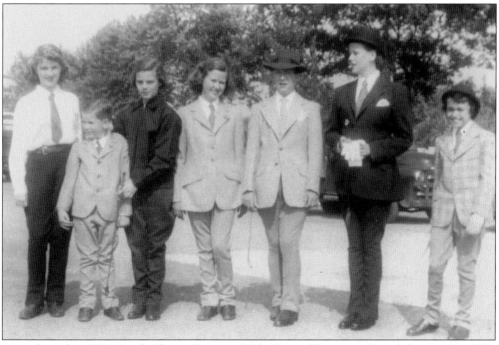

Attending the 1951 South Shore Country Club Horse Show are, from left to right, Sally Knowles, Tommy Morony, Nancy Greenawalt, Mary Morony, Danny McCarthy, Molly Morony and Maureen McNutry.

Nancy Greenawalt poses in the grandstand at the spring 1951 Horse Show.

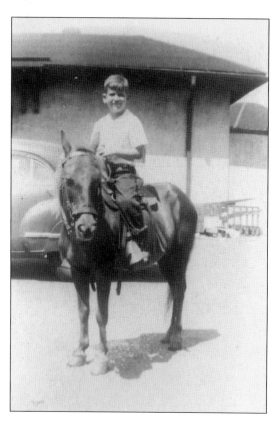

Tommy Morony is seen here riding Rodney the pony in a photo from July 1950.

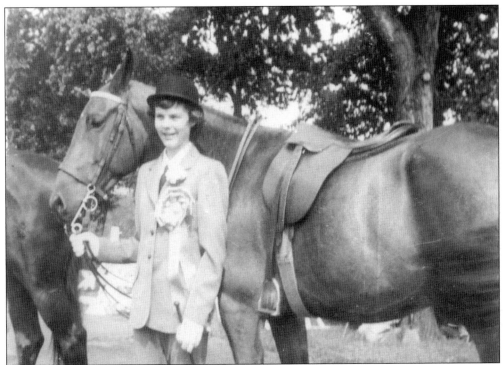

Nancy Greenawalt poses with Streamliner during the South Shore Country Club Horse Show of 1951.

Pictured at the SSCC Horse Show of 1951 are, from left to right, Nancy Greenawalt, and Mary and Molly Morony

Sally Greenawalt, Tommy Morony, and Susan Greenawalt enjoy the 1951 South Shore Country Club Horse Show.

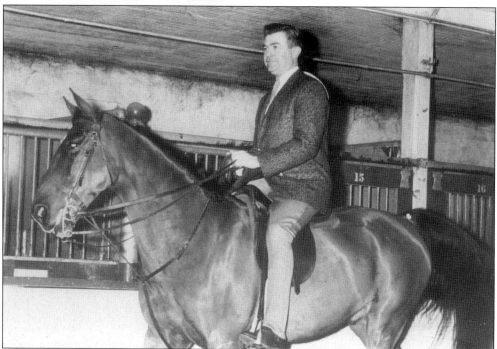

Admiral Thomas Stansbury rides his horse Delsie in this early 1950s photo. Admiral Stansbury's grandfather, Thomas A. Stevens, and his uncle, Charles A. Stevens, were both early members of the club. Thomas A. Stevens owned the Stevens Hotel, which would later become the Chicago Hilton and Towers.

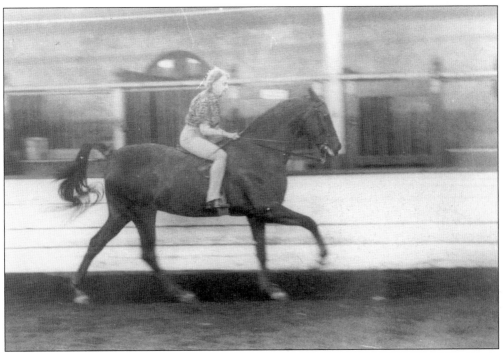

Elsie Stansbury is seen in this photo riding Kentucky's Pride.

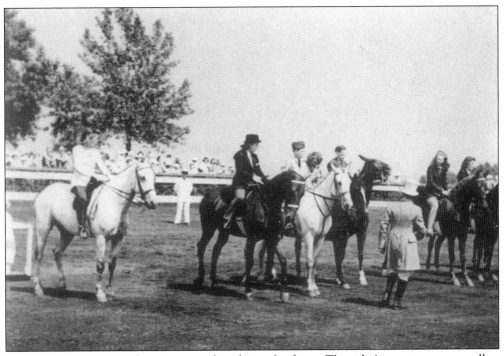

Elaborate equestrian outfits are pictured in this early photo. The rider's appearance, as well as that of the horse, was almost as important as the actual event.

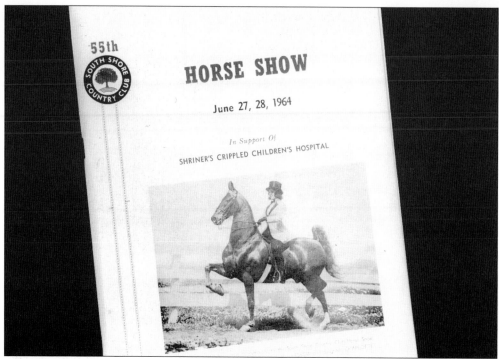

The 1964 Horse Show was held as a charity affair in support of Shriner's Crippled Children's Hospital.

Dr. Lois Stansbury poses with her daughter and their horse near the South Shore Country Club stables in this mid 1960s photo.

A young Barbara Rosborough takes the reins in this early 1960s horse show event. The horse show events had a large variety of categories for all ages and abilities.

Dr. Stansbury is pictured with her children.

In 1954, member Hal Higdon competed in track and cross-country for the University of Chicago. Hal captained the undefeated cross-country squad that won the Central AAU title and later was elected president of the University of Chicago Track Club. He went on to author the book *Crime of the Century* about the 1924 murder of Bobby Franks by Nathan Leopold and Richard Loeb.

Bill Tilden played exhibition matches on the clay courts of South Shore Country Club. He is pictured with Karel Kozeluh, the world's professional tennis champion. Other professional tennis players who played at South Shore include Helen Wills, Alice Marble, Bobby Riggs, George Lott, Frankie Parker, and others.

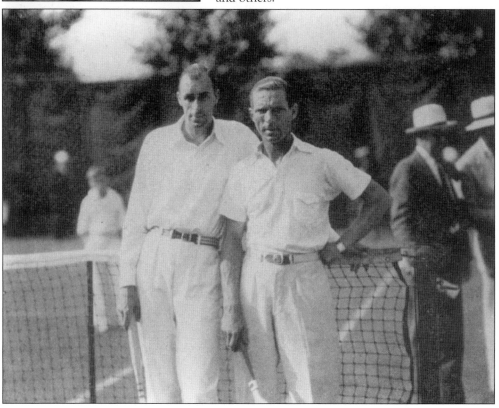

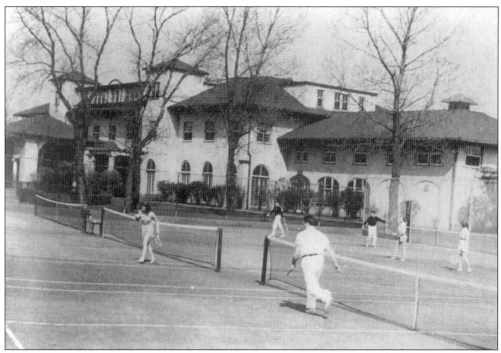

Tennis greats Bill Tilden and Bobby Riggs played on these clay courts. Between 1967 and 1969 the club, grounds, and tennis courts underwent a renovation in what was to be a last ditch attempt to attract new members.

Tennis players are pictured here enjoying a summer match on the clay courts.

Players are seen enjoying a sunny day on the courts in this 1965 photo.

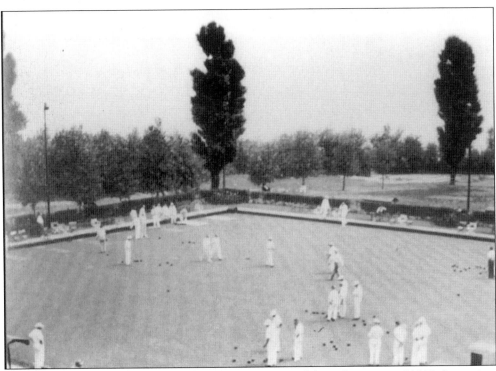

Lawn bowling was introduced at South Shore Country Club in the spring of 1940. Long time players continued to return to play on the grounds for years after the club was closed.

Arthur H. Hartley prepares to roll the ball on the lawn bowling green in this 1944 photo.

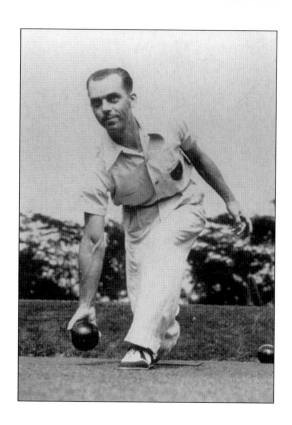

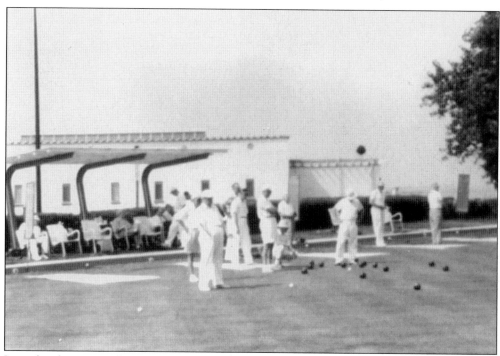

Lawn bowlers enjoyed a game as seen in this mid 1960's photo.

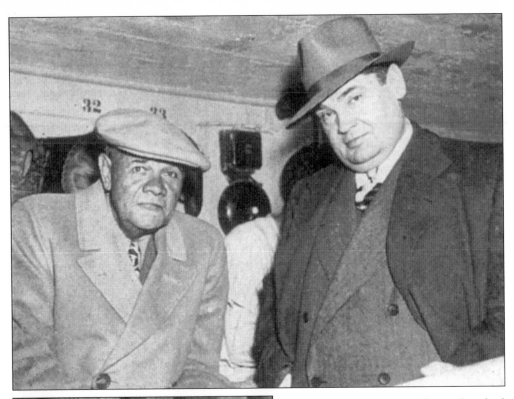

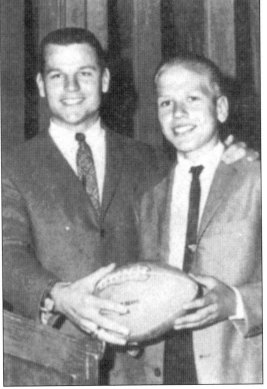

South Shore Country Club members had associations and friendships that stretched near and far. Member Emory C. Perry is seen here with the legendary Babe Ruth in the Yankee dugout on "Babe Ruth Day."

Johnny Morris of the Chicago Bears delivered a football to David Szyski at the 1966 South Shore Country Club Caddy Day event.

Billy Pierce, former pitcher with the Chicago White Sox and the San Francisco Giants, gave a speech on Caddy Day, 1966. Many sports figures attended events at South Shore Country Club. Mickey Mantle and Yogi Berra enjoyed a round of golf around the same time the photo at right was taken.

This is an early photo of the tee of the second hole, on the left just inside the gatehouse. This was a three-par hole parallel to the entrance drive.

Club champion Betty Naughton is pictured here with Class Champions, left to right, Mildred Matz, Jacie Davis, and Jo Moore. The photo was taken during a golf luncheon sometime in the mid 1960s.

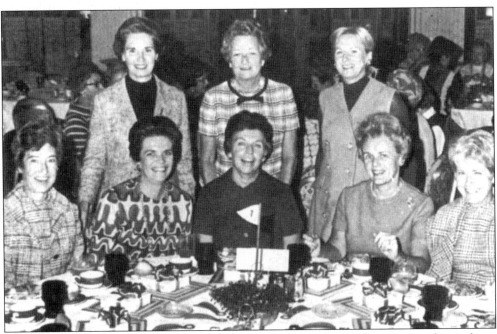

Some members of the Women's Golf Committee during the mid-1960s are shown here. Standing are Priscilla McCord, Dottie Piggott and Phylis Barnes; seated are Betty Hamilton, Roio Hartrich, Mary Jane Gibbs, Betty Naughton, and Evelyn McNichol.

The trees along the fairways at the club were both a landmark and a hazard.

Jean and Carol Kennedy posed on the lakeside lawn of the clubhouse in 1948.

Big Band leader Ted Weems practiced his aim at the South Shore Country Club Gun Club in 1937.

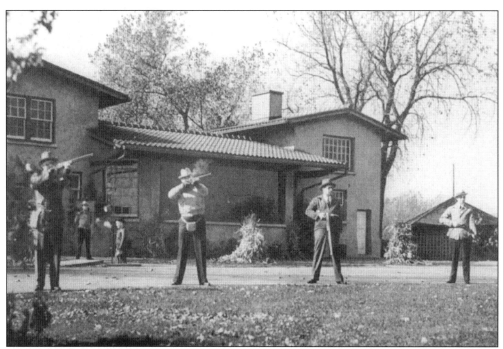

Gentlemen practice their aim in this early photo taken in front of the gun club building.

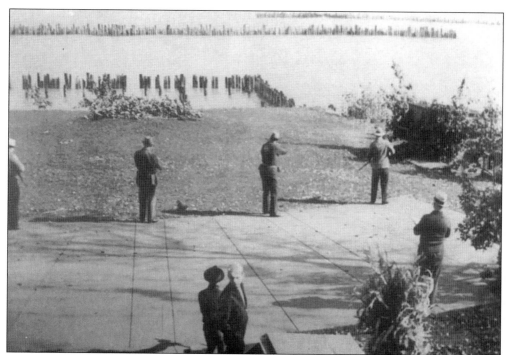

The lake provided a safe background for skeet shooting in this early gun club photo.

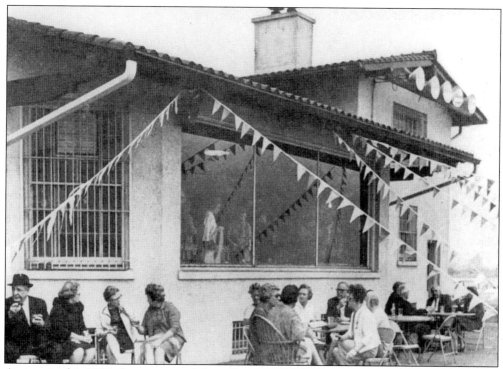

As seen in this 1967 photo, trap and skeet shooters and their guests watched exhibition events from both inside the shooting lodge and from outside on the patio of the gun club.

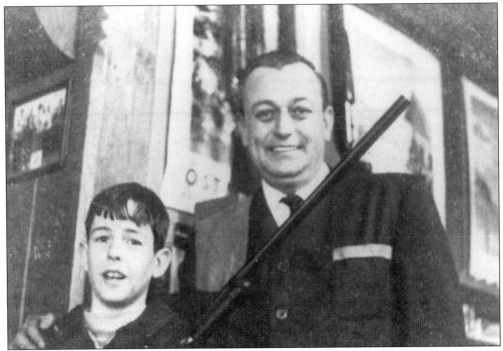

Local politician Phil Collins and his son posed outside the gun club in this photo from the late 1960s.

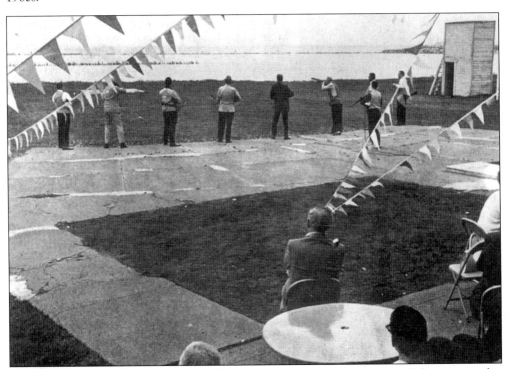

An audience of friends and visitors watched as gun club participants practiced their aim in this photo from the 1960s.

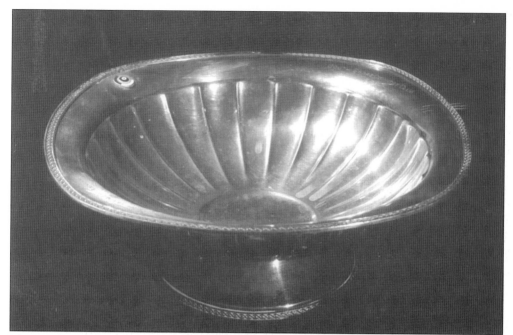

This trophy bowl was awarded for the 19th Annual Decoration Day Shoot in 1926.

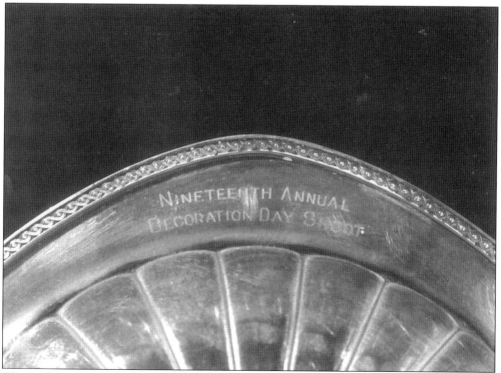

The trophy was inscribed with both the event and the name of the club.

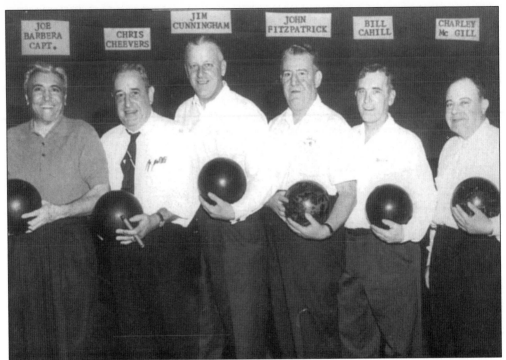

Members from the 1960 South Shore Country Club bowling league pose for a championship photo.

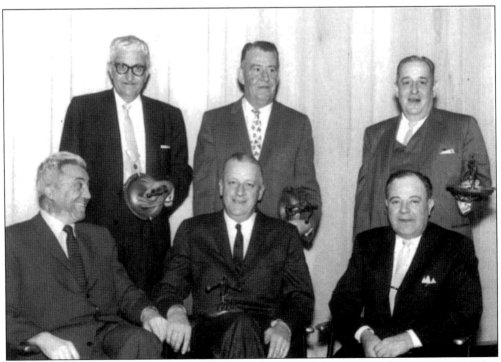

Members of the South Shore Country Club bowling league posed with their trophies for this 1960 photo.

102

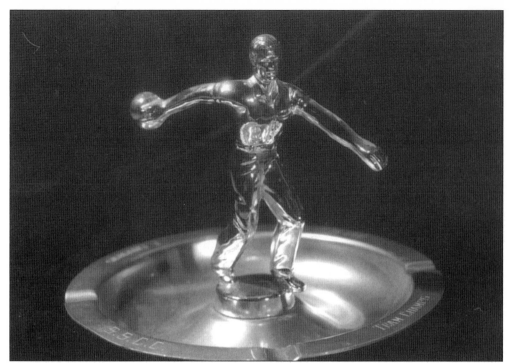

Indicative of the times, the trophy consisted of a small metal bowler mounted to an inscribed ashtray.

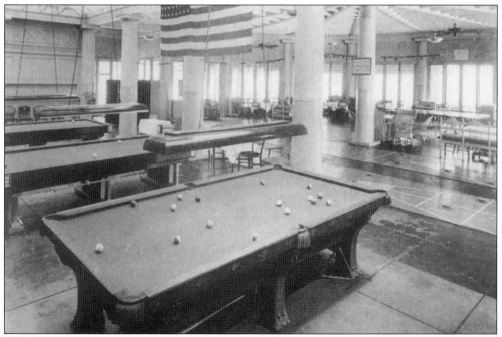

Billiards and shuffleboard could be played in the basement of the main clubhouse.

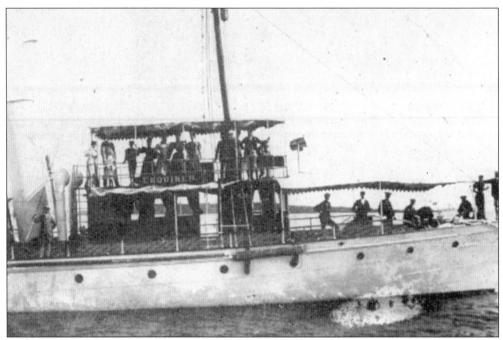

The Fred J. Wallach family and guests are seen in this photo aboard their yacht, the *Enquirer*. The Wallach family sold their business to what eventually became Eastman Kodak. At the time this photo was taken in 1907, Mr. Wallach had decided to sell the yacht. He didn't want to continue to spend the $75,000 per year to maintain and operate it.

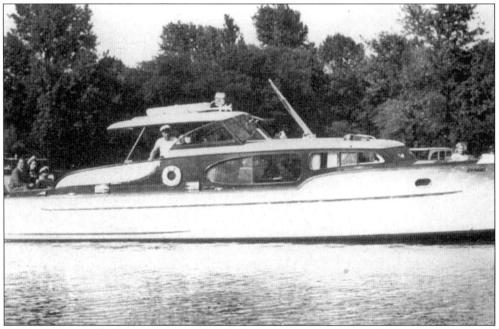

This 1948 photo shows the boat owned by G. Ivan Ostberg, the cruiser *Ivanhoe*. At one time it was not uncommon for members to cruise by the club on their yachts, or to dock them at nearby Jackson Park Harbor.

Four

THE END OF AN ERA AND A NEW BEGINNING

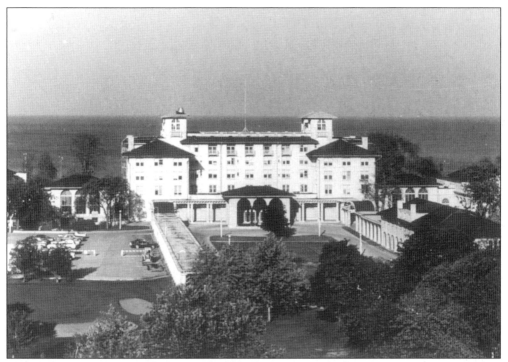

This photo shows the South Shore Country Club shortly before being sold to the Chicago Park District. By this time, the once meticulous buildings were beginning to show signs of age and deferred maintenance. During the last few years of operation, it was not uncommon to find a nearly empty clubhouse as membership dropped and former members moved to other parts of the city and suburbs. In 1974, the club was dissolved and the buildings were sold to the Chicago Park District. A time of new traditions began.

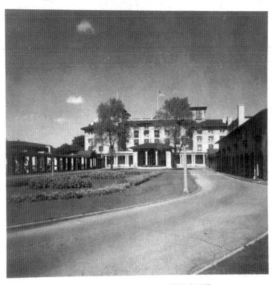

FINAL EDITION
JULY-AUGUST, 1974

VOICE OF
SOUTH SHORE COUNTRY CLUB

the green tree

SOUTH SHORE COUNTRY CLUB

1906-1974

The final issue of the South Shore Country Club monthly *Green Tree* magazine was combined for the last July/August 1974 issue. This issue was filled with stories and remembrances as it marked the closing of the 68-year-old club.

The members-only auction catalog featured 68 years worth of memories. This auction gave members an opportunity to purchase furniture, paintings, sculpture, china, and other items to serve as souvenirs. A public auction followed in which more utilitarian objects were sold. Many members came hoping to acquire something tangible to remind them of their "home away from home."

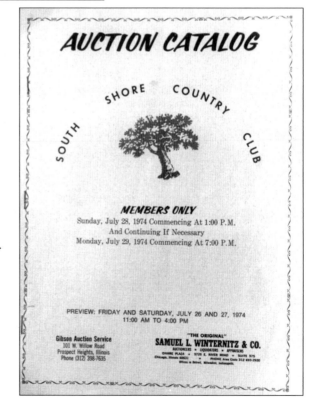

AUCTION CATALOG

SOUTH SHORE COUNTRY CLUB

MEMBERS ONLY

Sunday, July 28, 1974 Commencing At 1:00 P.M.
And Continuing If Necessary
Monday, July 29, 1974 Commencing At 7:00 P.M.

PREVIEW: FRIDAY AND SATURDAY, JULY 26 AND 27, 1974
11:00 AM TO 4:00 PM

Gibson Auction Service
101 W. Willow Road
Prospect Heights, Illinois
Phone (312) 398-7635

"THE ORIGINAL"
SAMUEL L. WINTERNITZ & CO.
AUCTIONEERS • LIQUIDATORS • APPRAISERS

The Cotton Ball, the last private event at South Shore Country Club, was held on July 14, 1974. This menu, autographed by many members brought together for the last time, reflected many heartfelt wishes, sentiments, and difficult farewells. Both current and former members came to this last event, with attendance at 1,430.

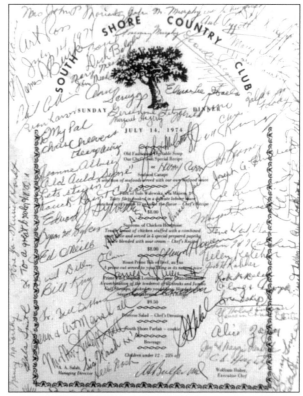

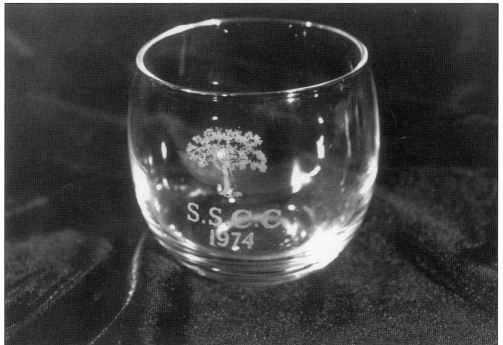

Etched cocktail glasses featuring the green tree and S.S.C.C., 1974 were used during the last event—the Cotton Ball on July 14, 1974. Members kept their glasses as a memento.

This photo shows a glass prism from an original 1906 chandelier. The grand ballroom was incorporated into the new building when the original club was moved. An original chandelier from the first clubhouse hangs in the solarium today.

The South Shore Country Club green tree logo was used on many items including this coaster and matchbook from the early 1970s.

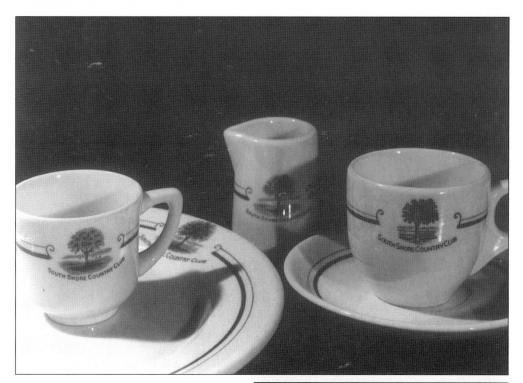

Dining room table settings were adorned with coordinated china and silverware.

This South Shore Country Club coffeepot is well worn, and turned up in an antique shop in rural Michigan in the early 1980s.

The South Shore Country Club china featured the green tree logo, a symbol used from the inception of the club until its closing 68 years later.

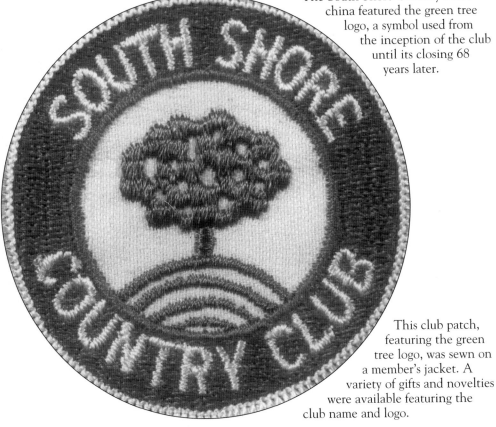

This club patch, featuring the green tree logo, was sewn on a member's jacket. A variety of gifts and novelties were available featuring the club name and logo.

This is the front cover of a breakfast menu from 1972. Breakfast was served between the hours of 6:00–11:00; lunch 11:00–2:00; and dinner 5:00–9:00. This was the schedule on a daily basis with exceptions made for occasions, parties, balls, etc.

Breakfast Menu

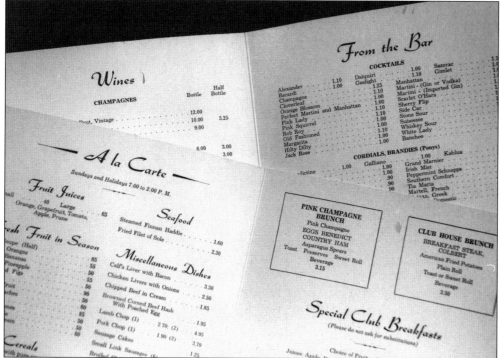

These samples of a breakfast menu and a bar menu from the mid 1960s reveal the plentiful choices available to members. The quality was always first rate.

South Shore Country Club

This menu provided a list of liquor offered at the club in 1970. A former headwaiter recalled a story from this era in which a group of 70 business executives managed to go through 140 bottles of alcohol at a single sitting. This was still at a time when the "cocktail hour" was socially acceptable and many business deals sealed by the mutual clinking of cocktail glasses.

South Shore Country Club offered its own private stock whiskey to its members. These were popular gifts among male friends and business associates, particularly during the holiday season. It is doubtful whether there was anything unique about its contents, but the label made for an impressive-looking product.

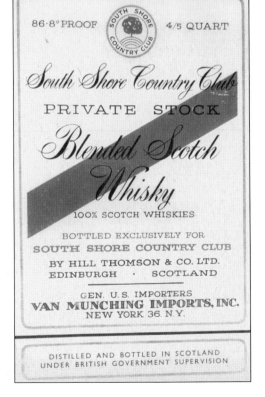

86·8° PROOF SOUTH SHORE COUNTRY CLUB 4/5 QUART

South Shore Country Club
PRIVATE STOCK
Blended Scotch Whisky
100% SCOTCH WHISKIES
BOTTLED EXCLUSIVELY FOR
SOUTH SHORE COUNTRY CLUB
BY HILL THOMSON & CO. LTD.
EDINBURGH · SCOTLAND
GEN. U.S. IMPORTERS
VAN MUNCHING IMPORTS, INC.
NEW YORK 36. N.Y.

DISTILLED AND BOTTLED IN SCOTLAND
UNDER BRITISH GOVERNMENT SUPERVISION

This 1965 Bird Cage menu featured snacks, drinks, and lunches for members coming off the greens or other outdoor activities. The environment of the Bird Cage included a dress code that was more relaxed.

This brochure featured the many amenities of the South Shore Country Club. This 1960s edition is an updated version of a similar one used in the 1940s and '50s. It extolled the benefits of club membership and was given to prospective new members.

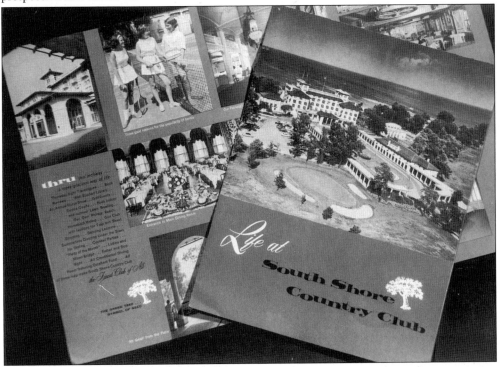

This booklet contained 20 coupons that could be torn off in 5¢ increments. The purpose of these coupons is unknown.

The *Green Tree* magazine arrived monthly at the homes of members. Each issue featured recent events, announcements, and activities. Members could view themselves and their family and friends participating in various activities. Upcoming events were addressed and announcements printed. Concerns were addressed and suggestions made by the board, as well as regular members. In later years, members were reminded to tell their friends about the club and to eat there regularly. It was also obvious in later years that the magazine had fewer pages, eventually becoming bi-monthly. There were fewer events and activities on the club calendar and many of the same, more mature faces were featured regularly.

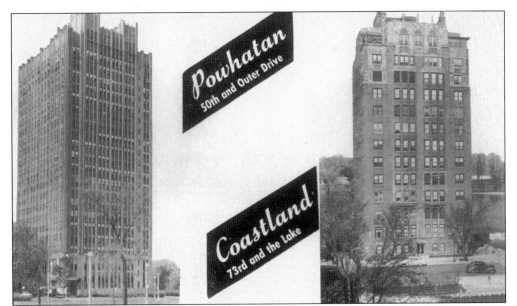

The Powhatan, at 50th and Outer Drive, and the Coastland, at 2666 E. 73rd Street, are cooperative apartment homes that were often the residence of South Shore Country Club members. The Coastland was the last residence of South Shore Country Club founder Lawrence Heyworth. Another resident of the Coastland was George E.Q. Johnson, who successfully prosecuted Alphonse Capone for income tax evasion.

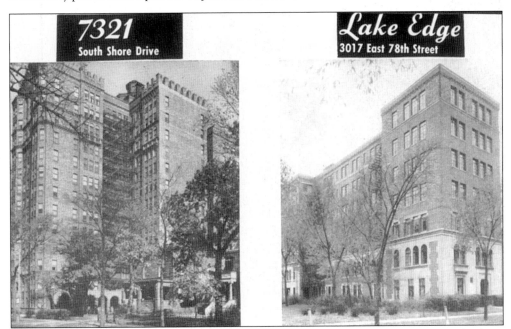

Two other popular cooperative apartment homes that were also home to many South Shore Country Club members are the 7321 South Shore Drive Building, once known as the Bannermann Building, and the Lake Edge Building at 3017 East 78th Street. All of these cooperative apartments were built in the 1920s and have many of the luxurious appointments that were popular in upscale residences of that era.

SOUTH SHORE COUNTRY CLUB

CHICAGO

July 18, 1974

Dear Member:

 South Shore Country Club is closed. July 14, 1974 was the last day to enjoy a beautiful part of our lives that had existed for many years. The Club staff is now preparing the many tasks that have to be done before the property is turned over to the new owners on August 19, 1974.

 It is hoped you were among the 1430 who attended the July 13th final party. It was a wonderfully, beautiful affair and proved what we all knew, that no one else has the facilities and the management know how, to do such a party as South Shore.

 Approximately August 1st, Miss Schwandt, our Executive Secretary, and Mr. Ahern, our Comptroller, and their important records and files will move to an office at 327 South LaSalle Street that shall become the headquarters of the Club until our affairs are completed. You will be advised later of details concerning this.

 The auction of the personal property of the Club will be held Sunday, July 28th and Monday, July 29th. This auction will be exclusively for members and the exact details will be given you in a very short time.

 In the meantime our efforts shall be directed toward disposing of the problems that stand in the way of making disposition of the assets of the Club to the equity members.

 Much has been said about the credit for the task of bringing about the sale of the Club. This has been without the shred of a doubt, a combined team effort. It started almost six years ago and has involved the intense, concentrated efforts of all the Club Officers and all the Board of Governors who were in office during this entire period. It has been too important and too enormous a task to be performed by any one, two, or three individuals.

Club president George M. Craig sent this letter to members informing them of the details pertaining to the closing and sale of the South Shore Country Club.

SOUTH SHORE COUNTRY CLUB

CHICAGO

-2- July 18, 1974

At the same time, great credit must go to the Committee Chairmen and the members of all the Committees, who while all these negotiations of sale have been going on have continued to run a Club that its members could enjoy and be proud of. They are all entitled to your thanks for a job well done under adverse and difficult conditions.

The excellent staff of the Club, headed by our Managing Director, Mr. Albert Salah, likewise deserve your thanks and appreciation. They have devoted themselves to continue your enjoyment of the 'finest Club of all'.

In closing, may I also say thanks to all of you for your understanding of the Club's problems.

We have all shared a wonderful experience. I wish there could be some way by which our personal relationships could be continued. Let me wish you good health, good luck and a great remembrance of our wonderful times at South Shore.

We shall be writing you again as matters progress.

Sincerely,

SOUTH SHORE COUNTRY CLUB

George M. Craig,
President.

117

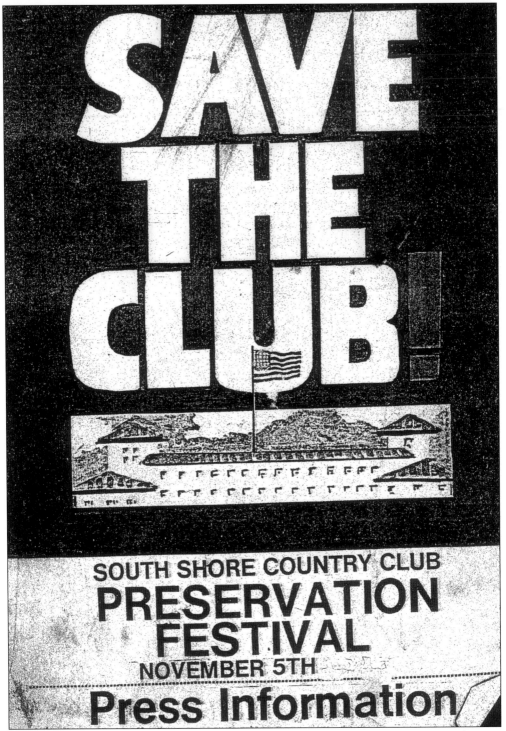

The struggle to save the former South Shore Country Club buildings became much more intense then the Chicago Park District had expected. One plan was to demolish the buildings and construct a new field house in its place.

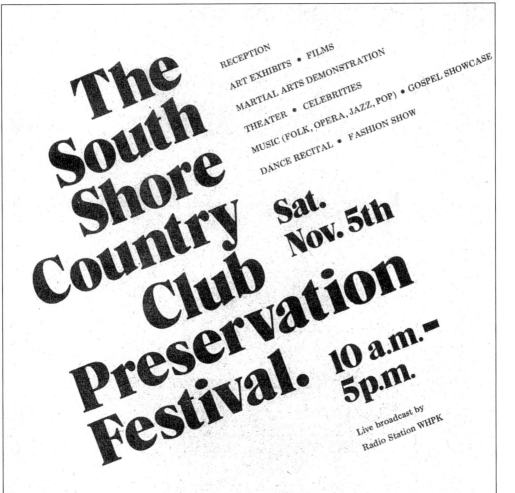

The decision to save and renovate the main clubhouse was heralded as a major success by the community and all those interested in historic preservation.

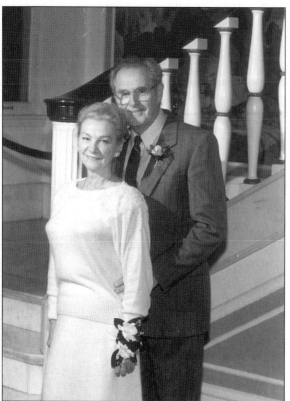

The South Shore Cultural Center has completed an extensive renovation and can be rented from the Chicago Park District for private events. Mr. and Mrs. William E. Krueger, parents of the author, are shown in November of 1986 celebrating their 40th wedding anniversary at the Center. Although the grandfather clocks are no longer present, the staircases are still a favorite place for photos.

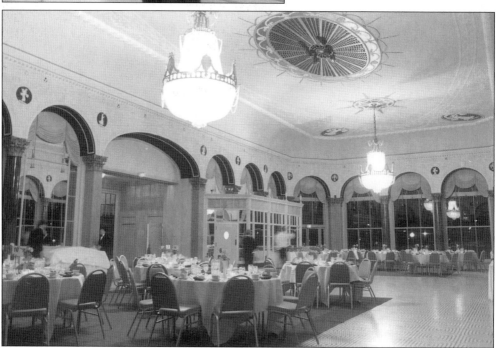

The main dining room of the South Shore Cultural Center recalls the elegance of the exclusive country club in what is now a public space.

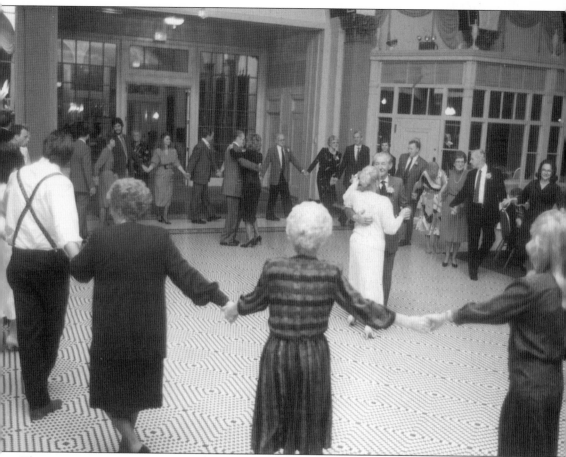

The rooms of the former country club still provide an opportunity for memorable events.

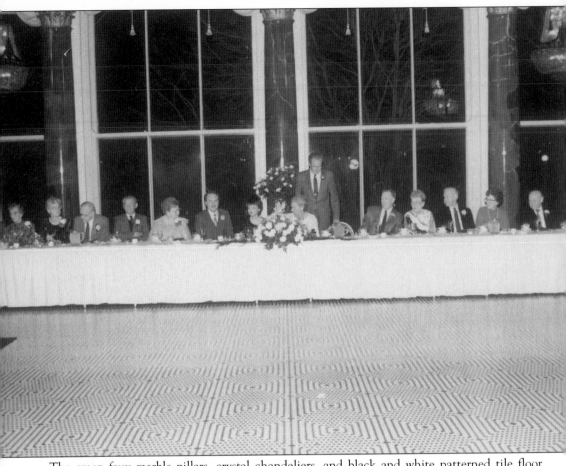

The green faux marble pillars, crystal chandeliers, and black and white patterned tile floor glistened once again after the park district renovation.

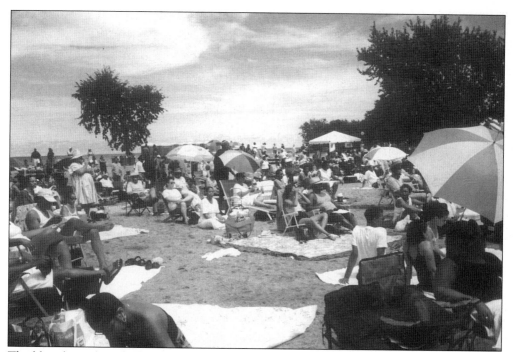

The blue sky and sandy shore provide an ideal background for a new tradition of live music at the South Shore Cultural Center.

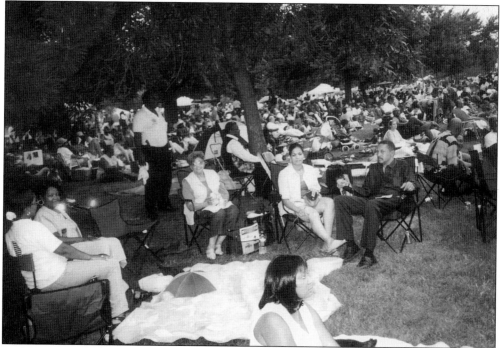

Each year, crowds gather on the broad expanses of lawn for Jazzfest, sponsored by the Chicago Park District and various corporations. Many top jazz artists appear annually. Dizzy Gillespie's last performance was given here.

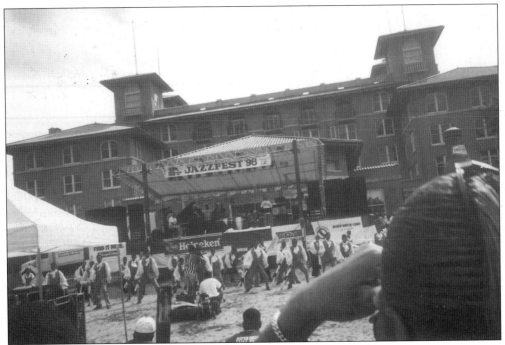

The South Shore High School Drill Team performs at the 1998 Jazzfest.

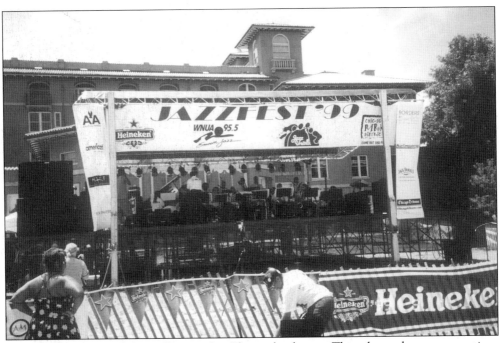

Jazzfest draws a crowd from all over the Chicagoland area. This photo shows preparations underway for the 1999 event with the clubhouse in the background.

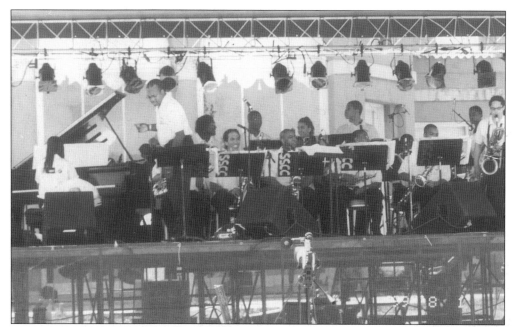

Ron Carter and the Northern Illinois Jazz Orchestra performed at Jazzfest on August 1, 1999.

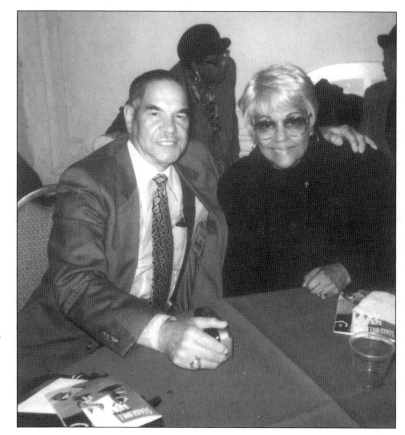

Mr. and Mrs. Henry Thomas, supporters of Jazz Unites and Jazzfest, visit with friends at the South Shore Cultural Center during the evening of the Northern Illinois Jazz Ensemble Scholarship Fundraiser. Faye Thomas' love for music goes back to the days when she traveled with her Aunt Marva, an entertainer and the wife of boxing great Joe Louis.

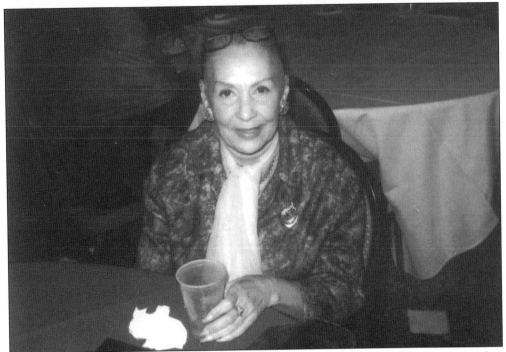

Mrs. Josephine Artus, jazz enthusiast and Jazz Unites promoter, performed in Chicago and in New York's Cotton Club. Mrs. Artus once owned a jazz club in South Shore called The Pumpkin Room, which drew top performers from around the country.

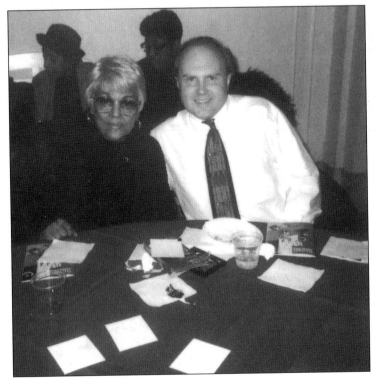

Faye Thomas of Jazz Unites and the author discuss the events of the evening during the Northern Illinois Jazz Ensemble Scholarship Fund Raiser.

In 1974, members of the former South Shore Country Club debuted their annual Green Tree Ball in a venue other than the club itself. The Drake Hotel was selected as the new home for this Christmas tradition.

SOUTH SHORE COUNTRY CLUB

CHICAGO

November 14, 1974

To: *Former Members*

SOUTH SHORE COUNTRY CLUB GREEN TREE CHRISTMAS BALL

DRAKE HOTEL — FRIDAY — DECEMBER 13, 1974
COCKTAILS — FRENCH ROOM — 7:00 PM
DINNER — GOLD COAST ROOM — 8:30 PM
DANCING — DINNER — ENTERTAINMENT — CASH BAR
$17.50 Per person
TABLES OF 8 or 10

This is the beginning of a new era. We're on our own in this "FIRST VENTURE".

Begin the Christmas Season by being with your friends from the "FINEST CLUB OF ALL". We expect to make this an annual affair.

Since this is the ONLY MAILING, to confirm your reservations, the enclosed card must be filled out and returned with your full payment by November 29th.

Your tickets will be at the door of the French Room.

Make check payable to: Green Tree Christmas Ball

Mail to: South Shore Country Club, 327 South LaSalle Street
Chicago, Illinois 60604

BLACK TIE

GREEN TREE COMMITTEE

TWENTY-THIRD ANNUAL
SOUTH SHORE COUNTRY CLUB
GREEN TREE CHRISTMAS BALL
FRIDAY, DECEMBER 13, 1996
AT THE DRAKE HOTEL

Black Tie $85.00 per person
Cocktails Dinner and Dancing
6:30 p.m. 8:00 p.m. - 1:00 a.m.
Grand Ballroom Gold Coast Room
Cash Bar Michael Lerich Orchestra

1996 COMMITTEE

Mr. and Mrs. Wm. Middendorf Mr. and Mrs. Edward M. Hogan, Jr.
Mr. and Mrs. William T. Dwyer, Jr.

The Drake Hotel has continued to host the affair since the 1974 transition. The rich tradition of the South Shore Country Club lingers on in the Green Tree Christmas Ball, even though attendance has lagged over time. Through the early 1990s, more than 500 continued to celebrate each Christmas. By the late 1990s attendance had dropped to below 400.

The once a year event allows former members and guests a chance to visit and share memories. The author and his wife Kathy visit with friend and former First Lady of the club Priscilla Finn. Priscilla was a long time member of the club, as were her parents. Seeing old friends and re-living the past was important enough for Priscilla to venture back to Chicago in December from her home in Indian Wells, California.

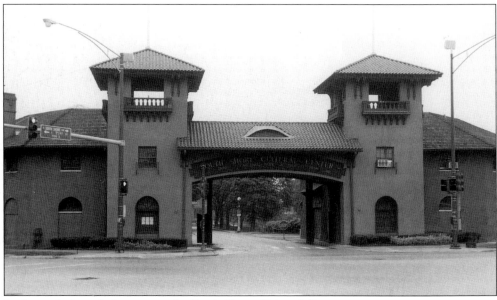

In the evolution of what is now the South Shore Cultural Center, some uses remain consistent within the framework of its historic past. Recreation, cultural celebration, entertainment, family bonds, and social interaction are as important today as they were when Lawrence Heyworth first considered creating a retreat for family and friends in 1906. In some ways it has always been a center of culture and a reflection of community. The South Shore Cultural Center continues this tradition.

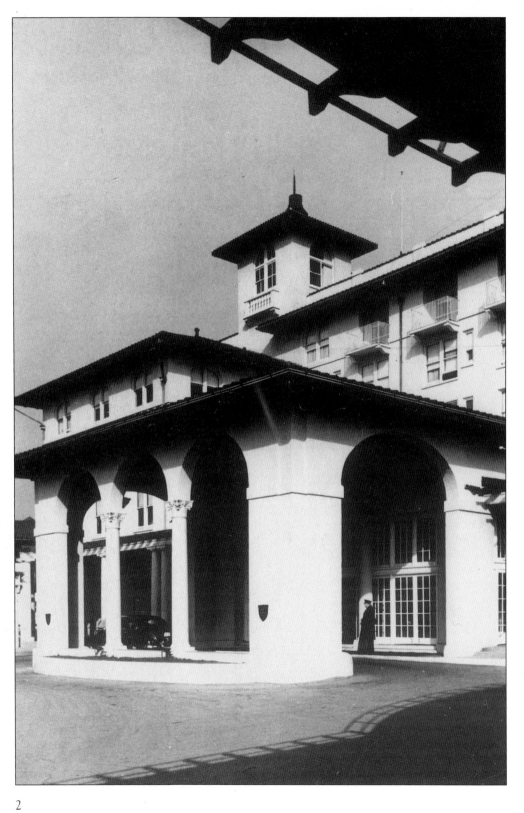

IMAGES
of America

CHICAGO'S SOUTH SHORE

COUNTRY CLUB